DRAW WITH JAZZA
CREATING CHARACTERS

FUN AND EASY GUIDE TO DRAWING CARTOONS AND COMICS

JOSIAH "JAZZA" BROOKS

IMPACT
CINCINNATI, OHIO
impact-books.com

CONTENTS

Required

- Pencil (mechanical pencil recommended)
- Pencil lead (if using a mechanical pencil)
- Sharpener (if using a traditional pencil)
- Eraser (kneaded or white plastic recommended)
- Paper

Recommended

- Non-Photo Blue or other colored pencil
- Ink pen or fineliner pen
- Ruler
- Coloring tools (markers, colored pencils, etc.)

Fun but Optional

- Digital software (such as Adobe Photoshop®)
- Digital tablet (such as Wacom)

DEDICATION

To my incredible wife, for your seemingly endless patience, love and support. And to my beautiful first-born son, the best character I've ever helped create!

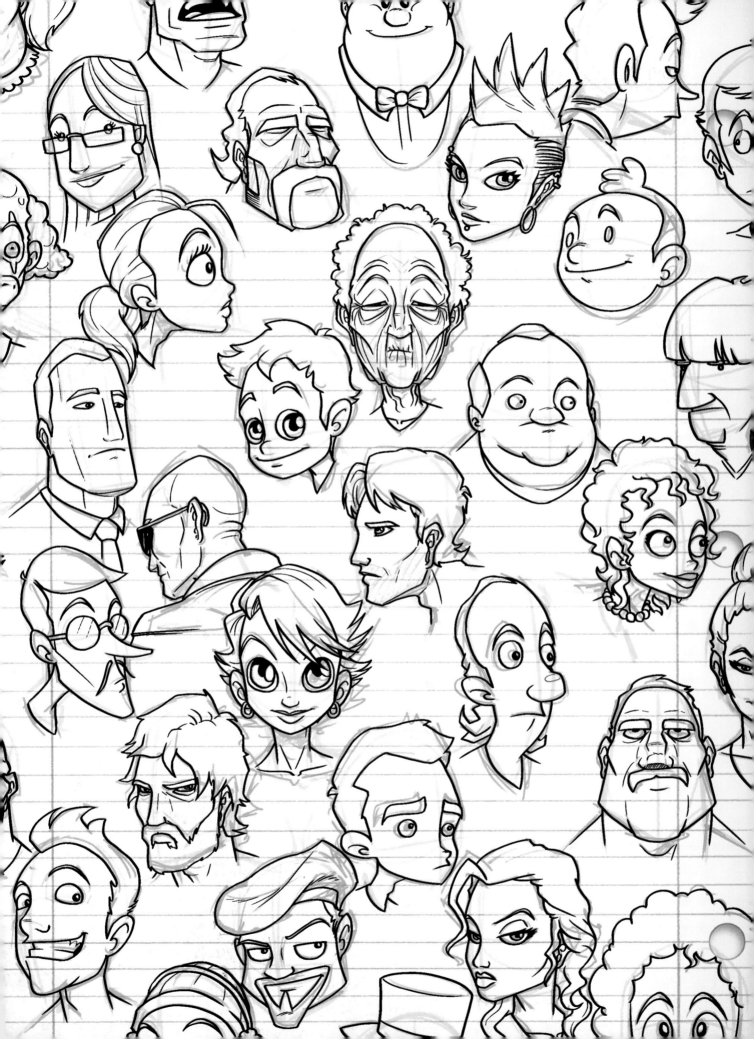

INTRODUCTION

You see them every day on television, the big screen, T-shirts, cereal boxes, books and more, in endless styles and themes. Some of them are so familiar, or are thought of so fondly, that they have become a part of our passions, hobbies and everyday lives. Characters, from Batman and Superman to the simple Reddit cartoon character, or from Mickey Mouse to the Balrog in *The Fellowship of the Ring*, were created through many hours of unseen planning, thinking, experimenting and revising. They were created using a method that I refer to as The Design Process.

There are many how-to-draw books out there that walk the reader step-by-step through drawing cool characters, and while this book does offer drawing tips and ideas, its primary purpose is to teach you how to effectively invent your own characters by applying the steps of the design process.

This process can be approached formally, but it can also happen naturally, without you realizing it. There are many variations of this process, and while the steps may be called by different names, the basic approach is always the same.

This book will demonstrate these steps for you in a simple, easy-to-apply method, and show you how to use them to effectively design your own characters for comic books, cartoons and more.

Let's get started!

OVERVIEW OF THE DESIGN PROCESS

As mentioned in the introduction, the design process has been explained in many different ways and used for a variety of applications. We're going to keep it as simple as possible and use the four *D*s:

1. **Discover:** The exploration of ideas, themes and visual styles.

2. **Design:** Loose play with brainstorm sketches.

3. **Develop:** Refinement of ideas and styles by narrowing down visual elements and testing the design for expected applications.

4. **Deliver:** Creation of finished art as polished concept art, character turnarounds, expression sheets and more.

By using these four steps, we can take an idea from concept to finished art with confidence. Through the design process, we create many ideas of what our character could look like, and then we narrow down and refine these designs using the process of elimination, until we are left with only one design.

VARIOUS APPLICATIONS

Throughout this book we'll explore the intricacies of the design process. It should be noted that this process is versatile and can be applied to many creative fields. In fact, if you were to look around and pick something in the room—a piece of furniture, a book, a toy, an item of clothing or a piece of technology—you can be certain that it has gone through the design process, in one form or another.

The design process involves exploration and refinement, both of which are required if we want to create anything new or noteworthy, or of high quality.

Versatile Process

Almost every product you see on a shelf has gone through the design process in one way or another.

DISCOVER

Although it doesn't involve putting pen to paper, you might be surprised to learn that the discovery stage of character design is just as important as the drawing. It's in the discovery stage that a solid foundation is created.

There's no harm in sketching out your ideas to keep your passion flowing, but at the very start of this journey, you've got to make sure you know where you're going. As artists, we can get pretty excited, and sometimes that emotion can make us race ahead without taking the time to make sure we're not creating something that has already been done, or doing something that means we'll have to come right back to the drawing board later!

Let's say, for example, that you want to invent a comic book character. Some people might assume that you would begin with sketches and drawings, but many potential problems arise if you skip the discovery stage. The visual presentation of your character should reflect the character's personality and history, so before drawing anything, those things need to be outlined. Who is this character? What are his or her motives, loves and hates? Where is the character from? What is it like in that world?

Remember, there are zillions of comic book characters out there, and most of them aren't very popular. So if you're creating a character for a comic book series, and you want your character to stand out from the crowd, there are questions you'll want to ask yourself. For instance, are there characters out there already that are similar to the one you want to make? What makes a comic book character popular? What types of people will most likely enjoy the story you're designing your character for?

All of these questions (and any others you think up) are important to explore as you set out to design a character that will make a lasting impression on your audience!

I know what you're thinking: This is boring, and I just want to draw my character *now*!

Well, calm down, Mr. Ants-in-Your-Pants. I promise we'll get to all the cool drawing stuff, but there's a very good reason that an entire section of this book is dedicated to the nondrawing stuff. As an artist, it's vital to learn to examine your (or someone else's) ideas, how you intend to apply them, and the context and medium in which they will be applied.

So, first off, are you designing your own character or someone else's?

Designing Characters for Yourself

If you're designing a character for your own project, you have the benefit of being the boss, making all of the decisions yourself and designing your character in whatever way you want. This freedom can be great, but it can also be a stumbling block, as we are not always our own best critics. To counter this problem, get some outside perspective from friends or family as you create your characters and projects. It can also be extremely helpful to treat yourself as your own client. Write yourself descriptions and set deadlines, outline your target audience, always make room for improvement and never skip steps.

Designing Characters for Someone Else

If you're designing a character for some-one else (such as a commission to depict a character from a novel or an avatar for your friend), the outline of the character's design and personality should be provided to you. It is your job to take this informa-tion and produce a representation that the other person is happy with. It doesn't mat-ter how brilliant you think the character you designed is; if your client isn't happy, you shouldn't be!

4 KEYS TO PREPARING YOURSELF

Whether you're designing a character on your own, ready to take on the world, or creating a character for someone else, it's important to be prepared and informed before designing anything. Here are some things to consider before racing ahead into the visual design.

Scope

How big is the project for which you're designing the character? Is it a simple character for a comic strip you'll produce yourself? Or will the character be used in an animation or game produced by someone else? Knowing the scope might narrow your design process to fit within specific parameters. For example, if you're designing a character for animation, you might need to keep the design simple and focus on how to use shapes and colors effectively.

Time

How much time do you have? If you're designing a character for your own purposes, and you intend to build a business or brand around this character, how will you effectively manage your time? If you're designing a character for someone else, is there a deadline? Have you allowed time in your planning as a buffer in case your client wants to make last-minute changes or tweaks?

Market Research

What is the context in which your character will be used? If it's for a comic book or cartoon, explore and research comic books or cartoons of a similar style or genre. Things are popular for a reason, so popular publications will have themes and characters that appeal to certain people. Outline aspects of characters that are worth copying and which elements are best to avoid or present in a new way.

Similar Projects

You don't want to accidentally invent a character identical to an already existing one! Make sure to investigate similar projects and avoid using too many visuals or themes from any one other character. The purpose of designing a character is to create an identity that's new and interesting to the audience. You don't want people to feel as if they've seen it all before.

CHARACTER BREAKDOWN

We need to be clear on the key aspects of the character, both physical and nonphysical. Sometimes spending time refining (or becoming familiar with) a character's personality will inadvertently shape the physical attributes as well!

PERSONALITY AND MOTIVES

Explore the character's depths—from their loves and hates, to their motives and flaws. Doing so will enable you to clearly understand how your character would act in any given situation, and developing these aspects can also help you refine how you may end up approaching visual elements of their design.

LOVES
- What brings them the most joy?
- What do they find attractive in people?
- Favorite color/food/animal, etc.?
- Hobbies and passions?
- What people do they most love?

HATES
- What triggers their anger quickly?
- What do they find most irritating?
- Do they have a prejudice?
- How do they deal with being let down?
- Who are their mortal enemies?

MOTIVES & GOALS
- What would the character most want to do tomorrow?
- Where would the character want to be in 10 years?
- Do they serve a higher power or authority? Why?
- What do they most want to learn or experience?
- What is the character's attitude about life in general?

FLAWS
- What are their bad habits?
- Do they have any physical limitations or quirks?
- What's their deepest, darkest secret or hidden shame?
- What physical or emotional scars do they have?
- What do others find most irritating about this character?

PLACEMENT IN CONTEXT

Your character will most likely exist in a world filled with history, society, aesthetic themes and loads of other people. When developing your character, it's important to take time to consider how they will impact, and be impacted by, the world and characters around them.

You'll be surprised how much a character's personality affects his or her physical attributes, and vice versa.

PEOPLE

- Name and describe 3-5 of the character's closest friends.
- Name and describe the character's enemies or competitors.
- Does the character have a pet or an animal companion?
- Does the character have any family? Who are they and where are they?

WORLD & SETTING

- What is the genre/setting the character will appear in?
- How important is the character to their world, and the world to the character?
- How important is knowing the world/setting to understanding the character?

PHYSICAL TRAITS

- What's your character's posture like?
- What kind of clothes does he or she wear?
- Do they move fast or slow?
- Are they heavy and clunky, or light and graceful?

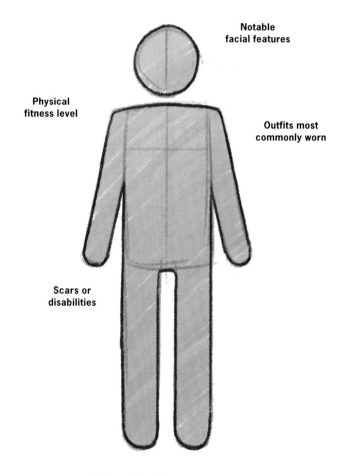

Notable facial features

Physical fitness level

Outfits most commonly worn

Scars or disabilities

Body type (fat, thin, muscular, etc.)

WORLD BUILDING

Sometimes the character you're designing is for a world or setting that already exists and is explained to you, and sometimes it's something entirely left up to you. A rich and interesting world will help further engage your audience and give them the feeling that your character exists in a real time and place.

BROAD WORLD VISION

It's important to have a vision of what the world you're designing for is like. This includes things like an aesthetic foundation. Is it a dark and gritty postapocalyptic setting, or a bright and colorful faery kingdom? What is the general social climate? What are the main challenges and triumphs of the population? Are there different social groups or factions? What are their various intentions?

GENERAL INFORMATION

- What do most people eat, drink, wear, enjoy or despise?
- How many people are there?
- What are the most important things to understand about the world or setting?
- What is day-to-day life like?

SOCIAL CLIMATE

- Who is in charge? What is the government?
- What are the major triumphs of the society?
- What are the society's greatest flaws?
- How free are people to express themselves?

PHYSICAL TRAITS

- How do people travel, build or dress?
- How is the world or setting visually different from our own?
- How is the world or setting visually similar to our own?
- What are the geography and environment like?

DETAILS, DETAILS, DETAILS!

It may seem over the top to delve deeply into world building when you really just want to get to your character's design. In reality, the world that character will be in acts as a foundation for every experience the character will have, and how the character will act or how other characters will act around them. Familiarity with the world you're designing for the character will make the design process much easier and immensely more enjoyable. Consider the following (depending on the relevance to your character):

NATURAL ELEMENTS

- Weather, climate, terrain, creatures, plant life, diseases, gravity, substances (metals, gases, water) and soils.

OTHER ELEMENTS

- Animals, foods, technologies or magic, pop-culture, crime, etc.

ALTERED ELEMENTS

- Buildings, rooms, social structures, currency, history, politics, foods, clothes and furnishings.

ASPECTS TO FOCUS ON

This is a lot to take on, and in reality, such depth is usually necessary in character design when the intended home of the character will be a comic book, TV show, movie or another large-scale project. Even for more modest-sized projects, however, it can be helpful to establish a few tiers of the most relevant world building elements.

TIER 1: Constantly Present and Highly Important

Examples: The home of the main character, the character's companion, spouse or child.

TIER 2: Often Present and Somewhat Influential

Examples: A boss at work, a best friend, favorite recreational places.

TIER 3: Sometimes Present, Not Very Important

Examples: A popular band or celebrity obsessed over by a close friend, a popular fictional drink.

TIER 4: Rarely Present, Not Important

Examples: Neighbors, politicians, shopping centers, etc.

There are two major influences on how your characters will be stylized. The first is simply your own approach and preference, which you will develop gradually over time. The second is what you're designing the character for, such as comic books, pinup posters, 2-D animation or 3-D animation.

COMICS

Graphic novels and comic strips allow for an endless range of visual styles. Simple stick-figure comic strips can be extremely popular, as can highly detailed comics. Generally, short-form comic materials (such as web comics) benefit from visual simplicity and clarity, while graphic novels (depending on genre and audience) can range from sleek and simple to extremely detailed styles. There are no right or wrong answers however, just general preferences.

2-D ANIMATION

Characters designed for animation have an innate limitation on how detailed they can be because they must be drawn and redrawn so many times and at so many angles. Characters for television animation, in general, are required to be simpler than characters designed for feature-length animation.

3-D ANIMATION

There are fewer limitations on how detailed a character can be for 3-D animation, because the detail doesn't need to be redrawn; however, there are often limitations of a more technical nature. For example, depending on the capabilities of the software and animators, there may be specific requirements for things like hair, cloth, certain textures and so on.

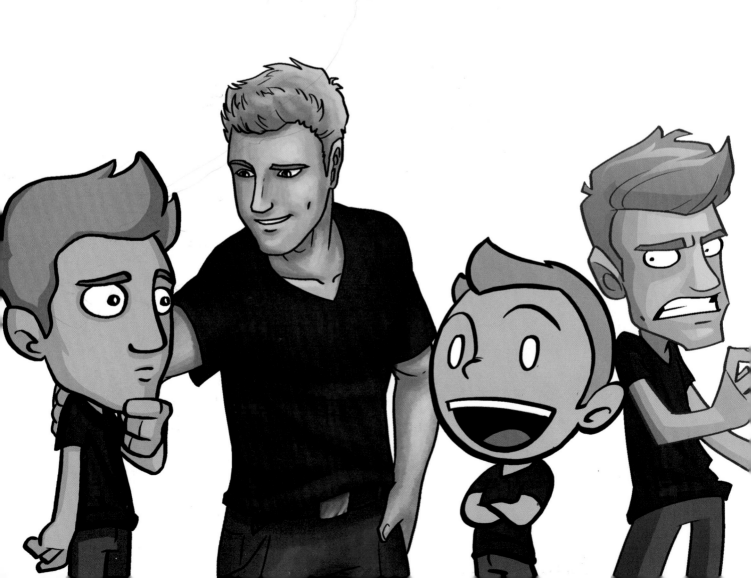

The Super-Simple Cartoon

These characters usually benefit from being "cute." When designing in a super-simple style, work with memorable and appealing shape combinations. Simple doesn't have to mean boring. You should always design your characters to be capable of extreme emotion or action, regardless of how simple they may be visually.

The Stylish Cartoon

This style is most suitable for comics or feature-style animation. Detail isn't rampant, but this style is definitely more involved to produce. The character will need to be designed so that it's clearly recognizable from many angles and with many expressions.

The Edgy Cartoon

Popular in television and animation, these blocky-looking characters rely heavily on silhouette, shape and color to maintain familiarity and appeal. Often in this style, there is a "shape language" that is prevalent throughout the entire world and setting. The cartoon may even seem to be cut out of colored paper, which can look really cool if done right!

Cutting-Edge Comics

In this style, details become more prevalent, such as lines conveying texture in hair and material, shading elements of solid black and hatching or cross-hatching, and more explicit anatomical details. Too much detail can be overwhelming, though, so when drawing detailed comic characters, make sure to allow areas of visual rest so the viewer isn't turned off.

Anime & Manga

With origins in Japan and Asia, there is as much versatility in visual style within anime and manga as there is in western comic books and animation. There are, however, a few common visual elements that are present in most anime and manga characters. These elements include a thin line style, often with sharper edges and straighter lines. Characters' chins and noses are often tapered and small or pointy. Eyes frequently have a bubbly look with more prominent eyelashes (top and bottom). Body proportions are straighter, with parallel lines and tall, lanky figures.

Semi-Realistic Comics

Drawing in a more realistic style often relies heavily on drawing with shading rather than lines. Gradients and textures can be used to create as much appealing realism as is needed. A realistic style doesn't have to mean an abundance of detail, but it does mean proportions and perspectives are built on realistic and familiar foundations to produce a result that's as believable as possible.

FINDING INSPIRATION

One of the most important aspects of the discovery stage is filling your head with ideas and inspiration by seeking visual references. The idea is to find things that fuel your creative process. If you're designing a pirate, go to Google Images and search for pirates. Save images you like, identifying what stands out to you and why. Explore websites that host artistic communities and look at work other artists have created around similar themes. Gather as much visual inspiration as you can and take it with you through the rest of the design process. You should never steal or copy someone else's design, of course, but taking the time to explore what has been done before, or what's accurate to the genre and setting around your character, will help you develop an understanding of what works well and what doesn't.

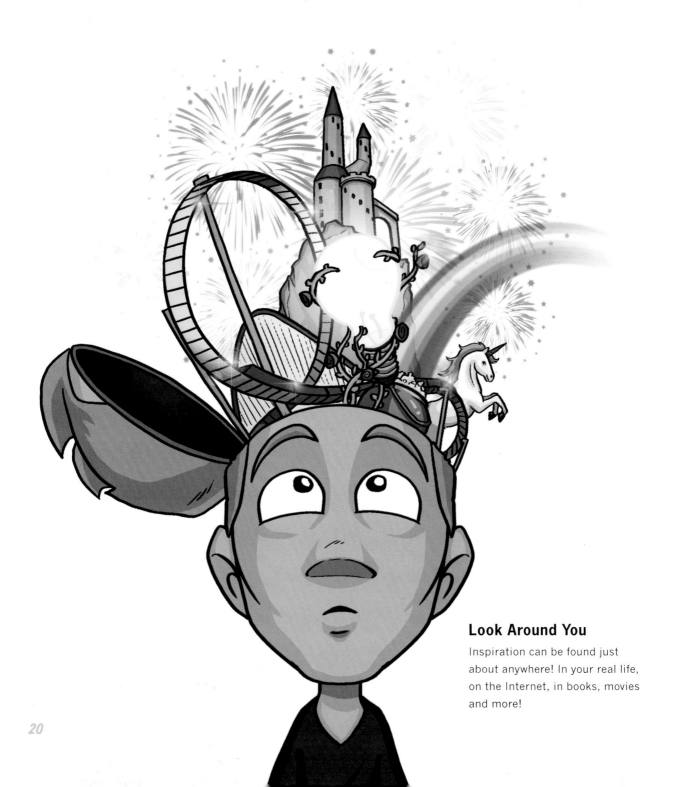

Look Around You

Inspiration can be found just about anywhere! In your real life, on the Internet, in books, movies and more!

FINAL PREPARATIONS

After all of that work, you're lined up at the starting gate, ready to race ahead. It's time to get your pencil, paint, stylus or whatever your weapon of choice happens to be, and begin your adventure!

Before you begin, here are a few things you'll want to be equipped with or informed of as you venture off on your artistic journey:

- **Clarity:** Make sure all of the information you'll be working with is available and organized. If creating a character for someone else, you may need to ask for this information. If you're creating your own characters, you'll still want to have your information laid out clearly so you don't have to stop or slow down to search for anything.

- **Tools:** Nothing is more disruptive to the creative process than being without a tool you need! Make sure you have plenty of paper, hard drive space or anything else essential to your process.

- **Visual References:** Being able to view any visual material you have gathered is important, as is being open to finding more material as you explore and refine your ideas.

- **Plans:** Know how long you'll be spending on any one project. Being late to a deadline or having a project drag on forever is an awful feeling. Use calendars and reminders to keep yourself on track.

STAGE 2
DESIGN

To design well, you don't need a beret, thick-rimmed glasses, a scarf, coffee or a pompous attitude (okay, coffee might help sometimes). What you really need is a lot of practice and an open, creative mind. Of course, there are specific talents that good designers have, including an eye for design and detail, and good instincts for shape and color. But all of these things are skills that can be developed and improved with time, practice and patience.

Don't give up if the first character you create isn't a global hit. Be patient with yourself and understand that the more characters you invent and design, the better you will become, and the more your work will stand out.

One of the best things you can do when putting pencil to paper is to remove self-judgment and allow yourself to become immersed in the process. Relax and allow your lines to be loose and rough. Don't get frustrated by "ugly" drawings, because there will be plenty of those! Just enjoy being creative and let yourself get excited when you find things you like (even small elements) and want to continue to work with.

Too often, artists will start with the intention to create a particular type of character in a particular style, and they'll do very little experimentation to achieve the results they want. This way of creating can prevent spontaneous inspiration. It also means that the designed character isn't the result of trial and error; rather, it's simply something close to what the artist initially had in mind. Without exploration, the artist might never learn that, perhaps, there are even better ways to approach the design.

Use the design stage to think openly, draw loosely and abandon self-criticism. Don't worry about whether what you're drawing looks good, or if it perfectly fits your initial ideas. As Bob Ross often said in his show *The Joy of Painting*, "There are no mistakes, only happy accidents."

Author's Note

Proportions and styles can vary a lot depending on the intended use of a character. When discussing the male and female bodies, I use typical comic book leading-man and leading-lady looks to demonstrate the fundamentals, then I apply these attributes in different ways through examples later in the chapter.

START SIMPLE

It can be intimidating to look at other artists' finished characters and artworks when you're learning to draw. That's because you don't see all of the sketches and failed attempts made in the process. The reality is that nearly all artists begin with simple sketches and shapes before they refine a piece with solidity and detail. Beginning a drawing with refined lines and details without any guides is like building a house without first knowing the floor plan!

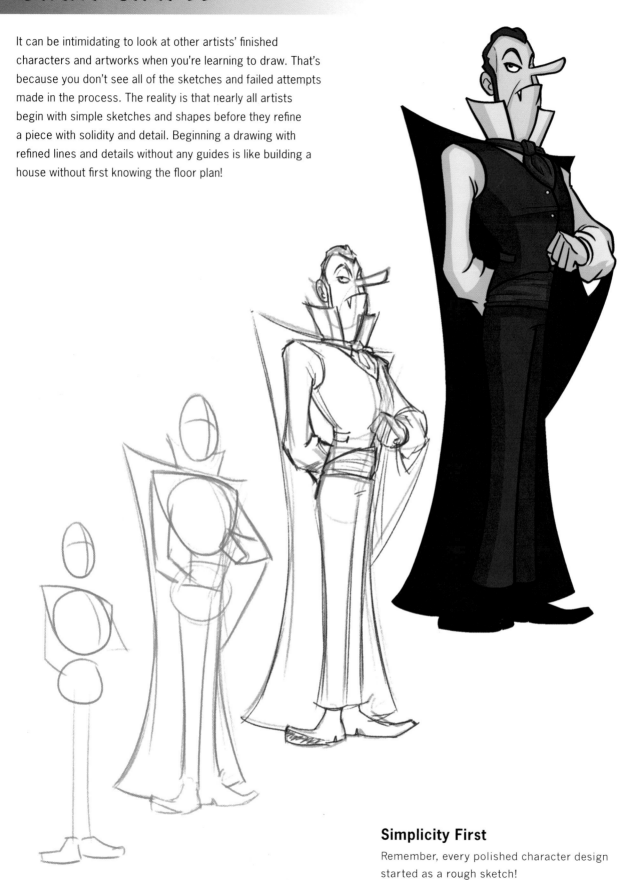

Simplicity First

Remember, every polished character design started as a rough sketch!

DECONSTRUCT, THEN CONSTRUCT

The human body is made up of many muscles, bones, veins and other complex parts. Memorizing them all (let alone drawing them) would be incredibly difficult and boring. Instead, we deconstruct the body into simple lines and shapes. We then use those simplified shapes as a foundation on which we can safely add more detail and solidity. This step is called construction.

Drawing Terms

In illustration, deconstruction means the breaking down of complex objects into simpler shapes. Construction means using those simple shapes to create a solid basis for an illustration.

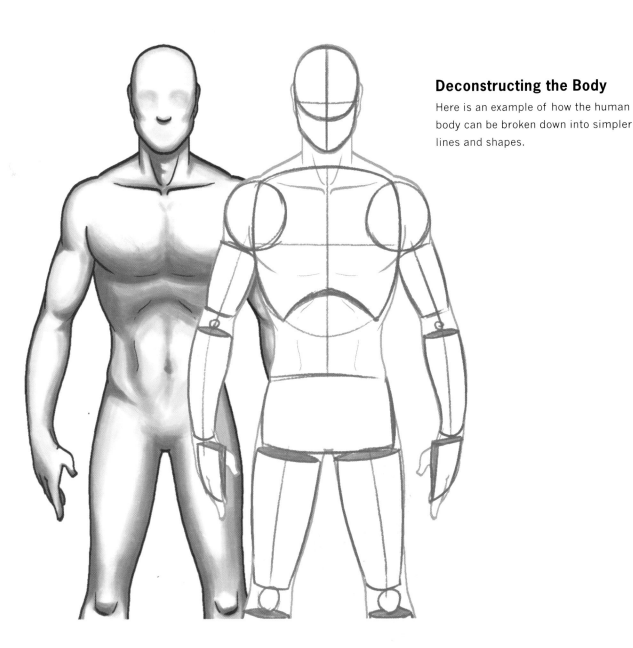

Deconstructing the Body

Here is an example of how the human body can be broken down into simpler lines and shapes.

DECONSTRUCTING THE HEAD

The human head can be difficult to draw, especially at different angles. By deconstructing the head into simple lines and shapes first, the process becomes a lot less complex. A common method of deconstructing the head is to break it down into four parts: the cranium, the jaw, the direction line and the eye line.

Guidelines

Neither the direction line nor the eye line are anatomical features. They are simply guides that aid you in representing the face at various angles, and in the placement of facial features.

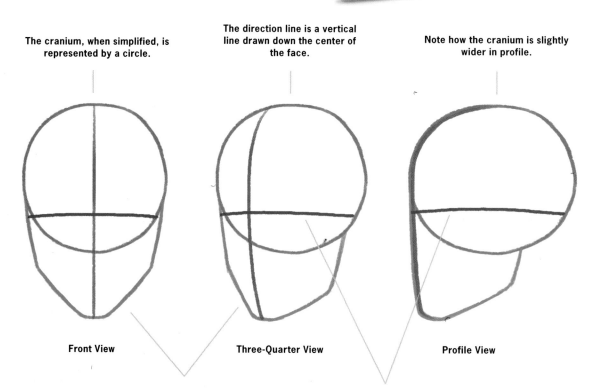

The cranium, when simplified, is represented by a circle.

The direction line is a vertical line drawn down the center of the face.

Note how the cranium is slightly wider in profile.

Front View

Three-Quarter View

Profile View

The jaw becomes a single line in a *U* or *V* shape that is connected to the cranium. Typically, the jawline is drawn with the lines of the top half being more vertical, and the bottom half tapering in to the tip of the chin.

The eye line is a horizontal line that indicates the axis on which the eyes can be drawn.

Direction Lines and Eye Lines

If we learn how to draw the simplified version of a head at different angles first, the task becomes more approachable.

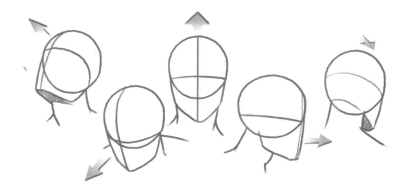

CONSTRUCTING THE HEAD

The use of simple construction lines as a foundation for drawing is common practice. Most artists draw characters at every angle, and construction lines streamline the process a great deal by keeping characters consistent and in proportion. They are easy and fast to draw, provide a clear understanding of the visual plan for an illustration and are much less frustrating to make changes to or discard than solid drawings.

Here are the steps I normally follow to build a face on top of construction lines:

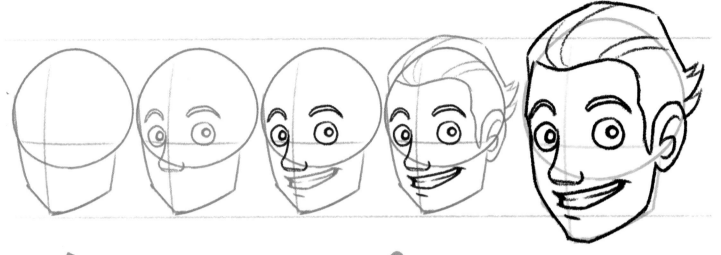

1 DRAW THE CONSTRUCTION LINES
Draw the head's construction with the proportions you want and facing the direction you want the character facing in the finished version.

2 ADD THE EYES AND NOSE
The first features to add are the eyes and the nose. The nose acts as a pointer in the direction the character is facing, and the eyes are the foundation of the expression.

3 ADD THE MOUTH
Next comes the mouth. Along with the eyes, it plays a crucial part in making your character expressive and appealing.

4 ADD FINAL FEATURES AND REFINE THE SILHOUETTE
Add the rest of the character's features, such as hair, ears and any facial props. At this stage, it's also wise to refine the shape of the facial silhouette from the solid flat shapes of the construction to a more natural shape that works well with the features you've added.

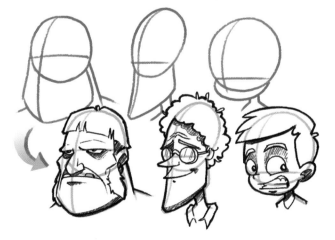

Using Construction Lines to Change Character Features

Once you're used to using construction lines to draw the human head, there are worlds of possibilities to explore! You can change the size and shapes of the cranium and jaw, or the vertical position of the eye line, to create completely unique and interesting characters.

WHAT MAKES A MASCULINE FACE?

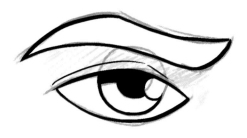

The Nose

A typical leading man will not have a prominent nose, but the nose will still have a strong shape with a slightly squared and blocky look. But feel free to have fun with noses. With some manipulation, they can make your character really interesting!

The Eyes

Male eyes work well when using thick, solid shapes. They are generally narrower with fewer details in the eye itself, such as eyelashes and shine highlights.

The Mouth

Less is more in the case of masculine mouths. Don't draw too much detail in the lips, as that will make them look fuller and more feminine. Also, too many lines in the teeth will make the mouth look dirty rather than detailed.

Facial Hair

Beards add a real sense of character to your design and are a clearly identifiable feature. Best of all, they come in all shapes and sizes, so there's a lot of playing around you can do!

WHAT MAKES A FEMININE FACE?

The Nose

A small, slightly upturned nose (with minimal detail) is a popular look for a feminine nose. Don't put too much solidity around the bridge of the nose, and when drawing the nostrils and tip of the nose, hint at or allude to their shape rather than outlining them heavily.

The Eyes

Sharp, angled eyebrows help create a feminine look, as does a rounder, almond-shaped eye. Eyelashes look more appealing when drawn in a cluster or as a silhouette instead of drawing each individual eyelash.

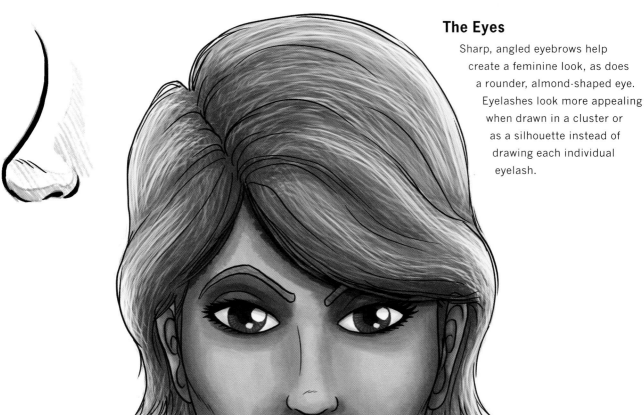

The Lips

Feminine lips are full and curvy. When drawing comic-book-style lips, think of the top ridge of the lip as following an *m* shape. When shading or coloring lips, the top lip is always darker because it's angled away from high light sources. Lips can be made more feminine by adding some shine.

DRAWING THE STEREOTYPICAL MALE FACE

Any forensic anthropologist will tell you that a human skull provides a good indication of a person's gender. Therefore, we need to keep certain attributes in mind when drawing a male or female head. For instance, males typically have squarer jaws and solid, square noses. Their necks and eyebrows are often thicker than a female's, too.

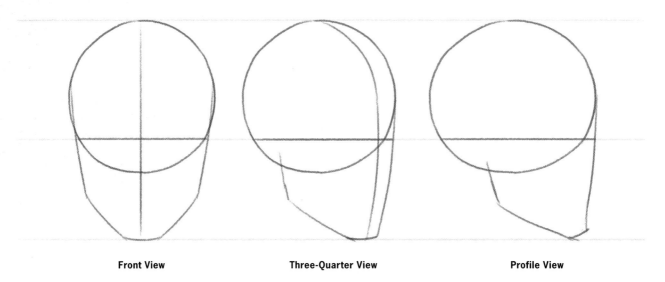

Front View　　　**Three-Quarter View**　　　**Profile View**

1 CONSTRUCT THE HEAD
Draw construction lines for the basic head first, using a few simple lines and shapes, to act as a foundation for the rest of your drawing.

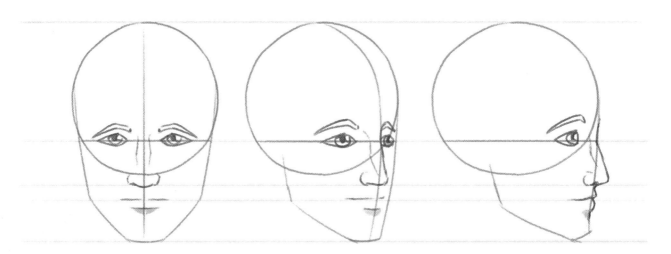

2 DRAW THE CORE FACIAL FEATURES
Add the core facial features: the eyes, nose and mouth. Note how their proportions change depending on their angle. For example, the eyes are an almond or round shape in the front view, and they graduate toward a cone shape when the head is in profile. Also note how, when the head is in profile view, we break past the construction lines of the face to show the nose protruding and the angles of the mouth lines.

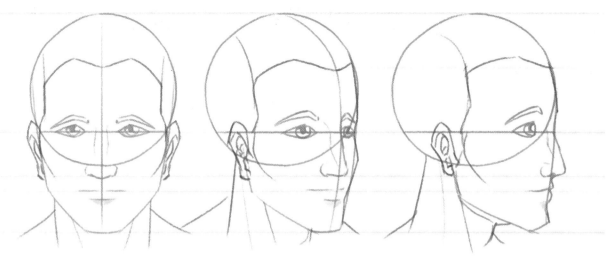

3 REFINE THE HAIR, EARS AND FACIAL SHAPE

Add additional features to the face, including ears and hair. Refine the shape of the face to work with the features you've chosen. At this point, add any additional features or props that will be part of the character's face.

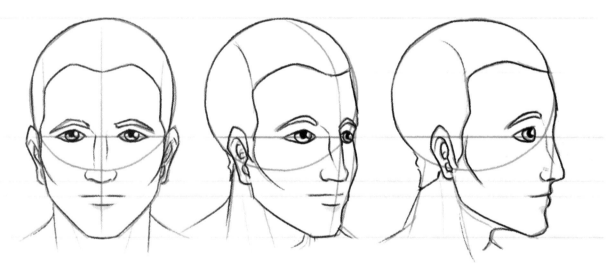

4 CREATE YOUR FINAL IMAGE

Finish by refining the lines. The lines of your final refined image will need to be cleaner than your construction sketch, and you'll need fewer of them. In this stage, every line makes a big difference, so don't overuse them!

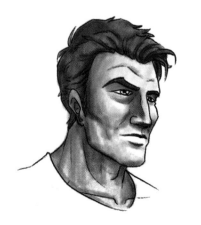

Masculine Details

When drawing a particularly masculine man, blocky lines and edges work well. Drawing lines for detail in the main areas of the face, such as the cheeks, eyes and nose, can add a look of age and masculinity.

DRAWING THE STEREOTYPICAL FEMALE FACE

In general, shapes are softer and slightly more angled on a feminine face, and the face itself often works best with less detail. If you add too much detail around the nose and face, your female character will look weathered or aged.

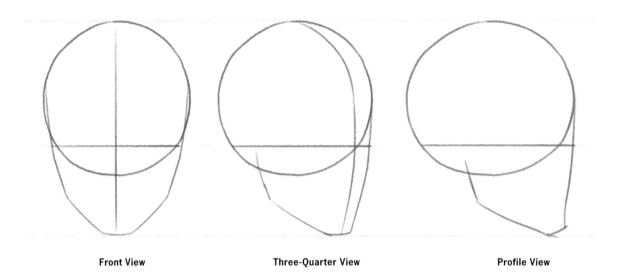

Front View **Three-Quarter View** **Profile View**

1 CONSTRUCT THE HEAD
Draw construction lines for the head. The geometry for a feminine head is curvier than a male's. The jaw angle is less blocky and more tapered.

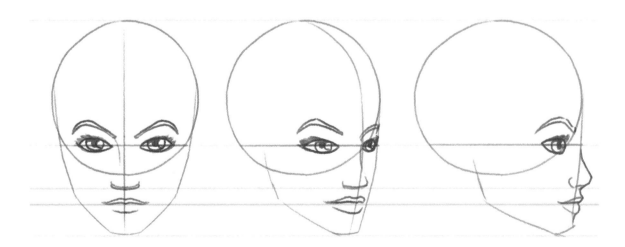

2 DRAW THE CORE FACIAL FEATURES
Add the core facial features: the eyes, nose and mouth. Typical feminine faces have larger eyes with a slight angle to them, with a smaller nose and mouth.

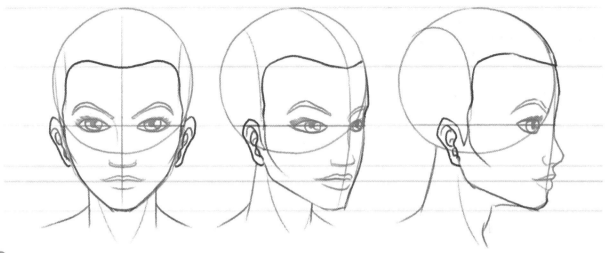

3 REFINE THE HAIR, EARS AND FACIAL SHAPE

Add additional features to the face, including ears and hair. Refine the shape of the face to work with the features you've chosen. At this point, add any additional features or props that will be part of the character's face.

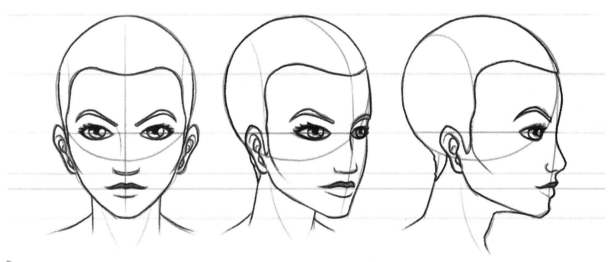

4 CREATE YOUR FINAL IMAGE

Finish by refining the lines. Remember that the more lines in a particular area (and the thicker they are), the more attention they draw. This can be used effectively by having bolder lines in the eyes and lips to create a feminine look, while using minimal lines in the nose and other details of the face.

Feminine Details

Comic-style heroines often have a feline look. Soft, round cheeks make for an appealing feminine face, as does a slight slant to the eyes and a longer, thinner neck.

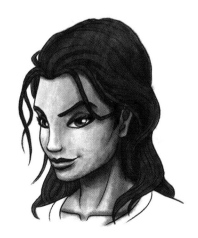

BASIC BODY CONSTRUCTION

The techniques used to simplify and reproduce the human head can be applied in the same way to the rest of the body. It's a little trickier, however, since the body is more complex. To make the process easier, we can draw the body in stages of solidity.

By drawing a simple skeleton at the beginning, it's easier to draw poses and plan proportions. Getting the basics right at this stage of the illustration saves time later on.

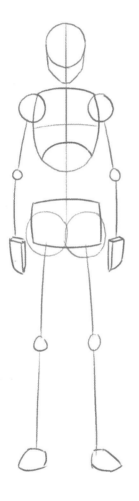

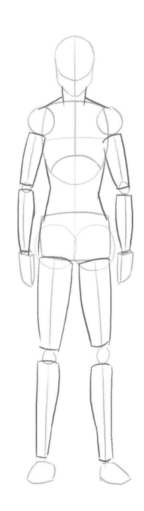

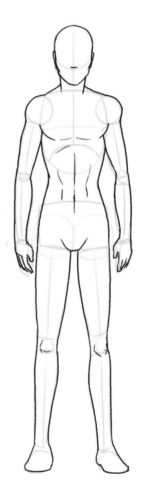

1 CREATE THE SKELETON
Draw the body with simple lines and shapes to represent the human skeleton. The largest areas of a skeleton are the skull, the torso (rib cage) and the pelvis (hips). Draw the limbs with simple lines and circular shapes for the joints.

2 ADD MEAT TO THE BONES
Once we're happy with the skeletal construction, we can build up the silhouette (or outline) of our figure by drawing simple shapes that represent the largest areas of mass. The meat of the arms, legs and neck can be drawn as cylinders to help us plan how the body will be built up.

3 REFINE THE SHAPES
With the foundations in place, it's much easier to give shape to the figure and add details.

DECONSTRUCTING THE TORSO

The torso can be confusing to draw, but the process becomes easier when we draw figures using a construction skeleton first. The rib cage can be represented with very few lines and shapes while still clearly communicating its form.

Shown here, the rib cage is drawn with both vertical and horizontal direction lines. These help to indicate which direction the torso is facing and give it a three-dimensional feel. Making the ellipse concave at the bottom of the rib cage is optional, but it can be helpful when drawing people on difficult angles or in complex poses.

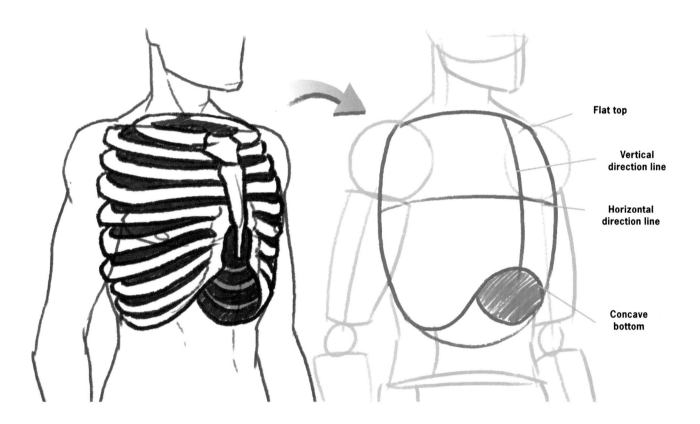

Flat top

Vertical direction line

Horizontal direction line

Concave bottom

Simplify the Torso

The rib cage can be simplified by drawing an ellipse with a flat top, making it concave at the bottom and adding some direction lines.

DRAWING THE STEREOTYPICAL MALE BODY

The average masculine adult male is tall with broad shoulders and thick limbs and torso. As with the face, solid, blocky lines and shapes create a strong visual aesthetic. There are, of course, all shapes, sizes and body types, but this will be our foundation example. We'll get to play with some fun variations later in this chapter!

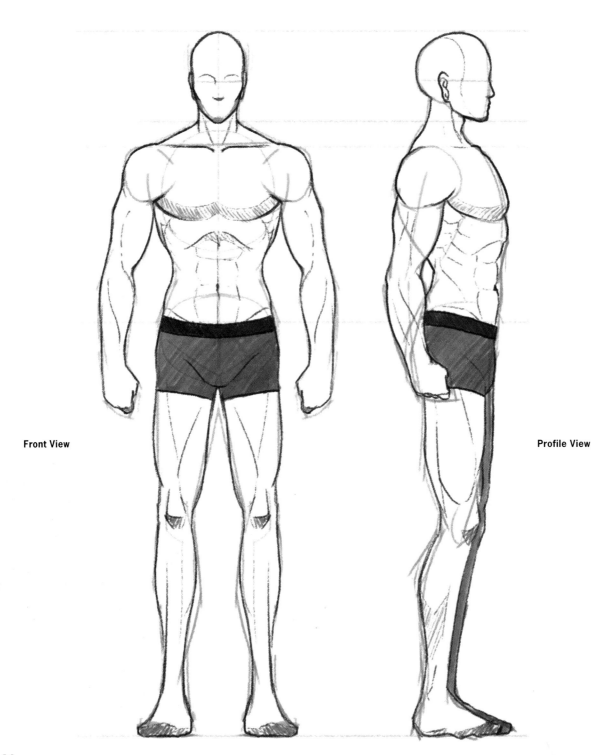

Front View

Profile View

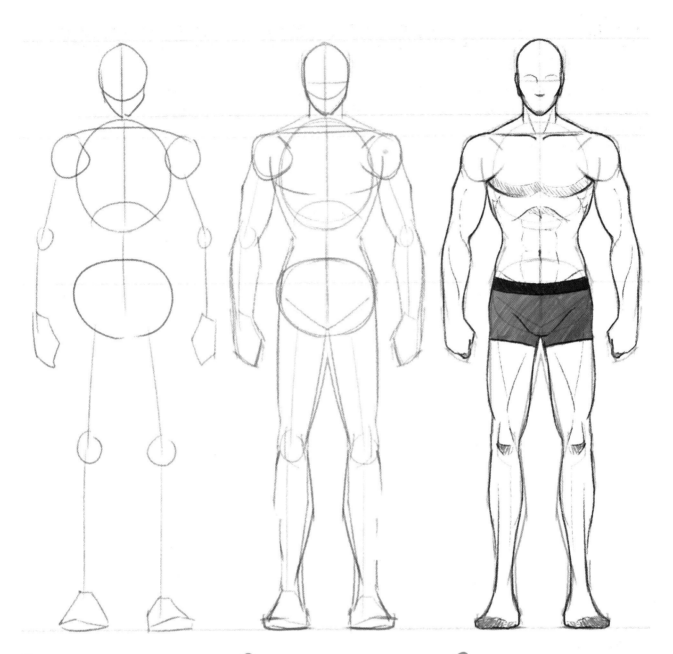

1 CREATE THE SKELETON

The primary purpose of starting your drawing with a construction skeleton is to test the posture and pose of your character (this is also referred to as gesture drawing). For example, a typical leading man will often have wide shoulders, straight legs and an upright chest. This creates the appearance of confidence and strength.

2 BLOCK IN ROUGH ANATOMY

Thicken the skeleton into what will be the final silhouette of the character's physique. This is a key part in effectively communicating the core physical attributes of the character. For example, there are a few areas on a male body where having solid blocks of mass will make them look particularly masculine: the shoulders and the chest, primarily, and the upper arms and upper legs, secondarily.

3 REFINE AND DETAIL

When drawing refinement lines of a character's anatomy, try to use lines as efficiently as possible. Too many lines will make your character look busy and unrealistic, while not enough will make him feel unfinished. Prioritize the aspects of your character that best communicate their personality and traits. For example, a fat character will need extra lines under the areas of largest mass to show the weight on their body, while a muscular or athletic male will need lines in the areas mentioned in step 2 (the shoulders, chest, upper arms and upper legs).

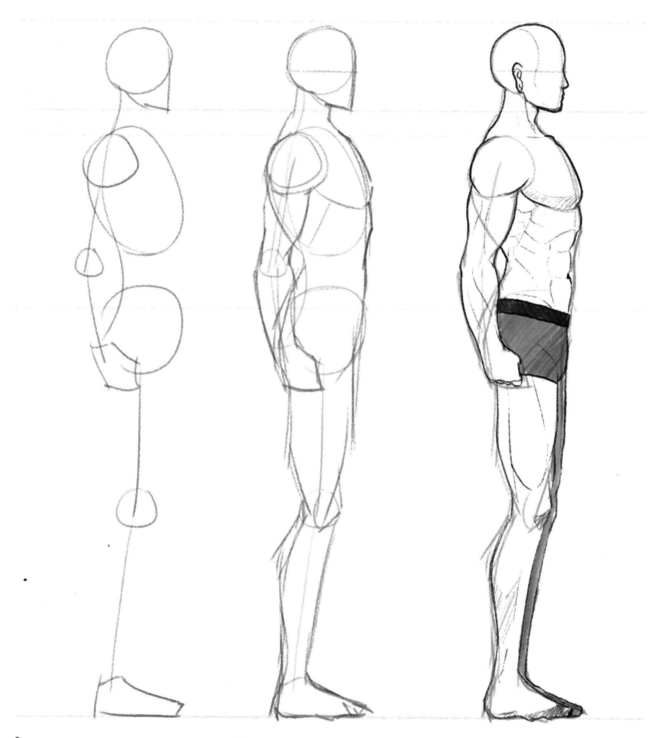

1 CREATE THE SKELETON

When in profile, a masculine pose works best when the head is upright, the chest is high and pushed forward, the back is slightly arched and the feet are straight and in a strong position.

2 BLOCK IN ROUGH ANATOMY

When the arms are pulled back and the chest is puffed out, it looks like the person being depicted is ready for action, either to leap in and attack or to defend. It is the opposite of a neutral or relaxed pose, which is slumped in the shoulders with arms forward and legs bent.

3 REFINE AND DETAIL

A character's silhouette refers to the shape and outline of the figure and what the image would be communicating if it were a solid, flat, single color. For a masculine posture, the silhouette should show the lines of the jaw and upright head, and the shapes of the chest, shoulders, arms and legs clearly, which accentuate the visual strength of the pose.

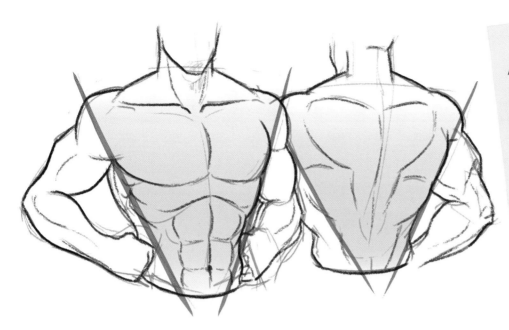

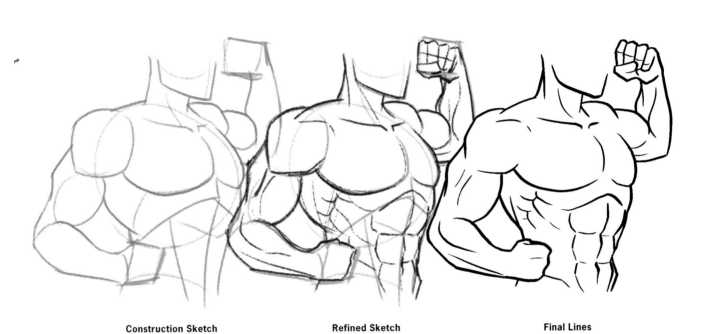

Construction Sketch **Refined Sketch** **Final Lines**

Muscle Construction

Muscles, like everything else, are drawn using basic shapes first. The largest shapes will always be used for the primary construction (in this case, the shoulders, biceps and triceps), around which the smaller and more intricate muscles can be constructed if the character you're drawing requires more detail. Once the construction is complete, think of the final lines as drawing the skin on top of the raw muscles. You won't need to draw every dividing line and shape. Just signify where the largest muscle groups connect by drawing lines in the connecting corners of these shapes, where the folds and creases would be deepest.

DRAWING THE STEREOTYPICAL FEMALE BODY

The stereotypical female body has elegant curves, with an hourglass shape in the torso, and dainty or soft-looking limbs. This is, of course, not what every woman does or should look like, but it is a general approach for a leading lady, and a good starting point.

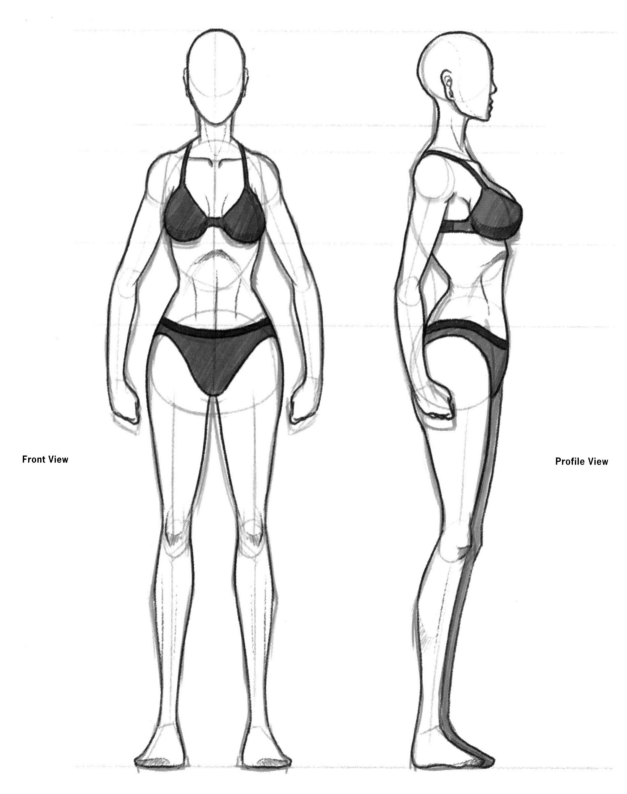

Front View

Profile View

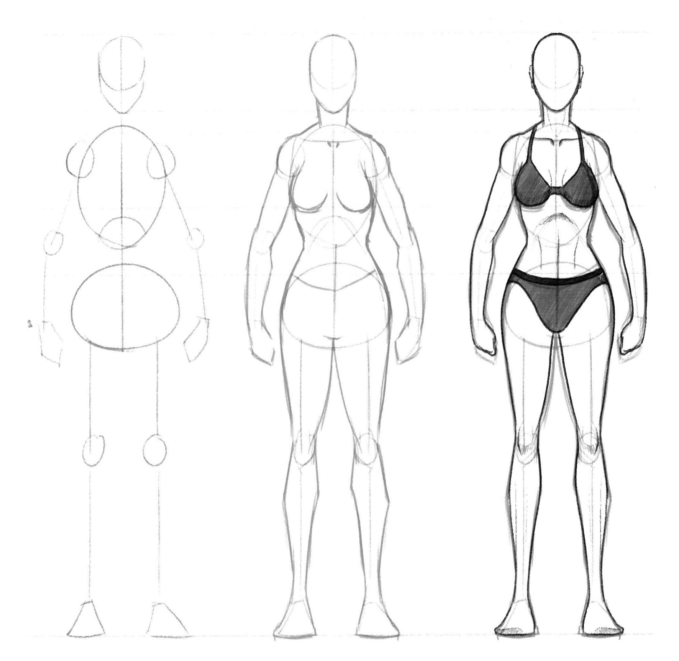

1 CREATE THE SKELETON

Female hips are typically wider than a male's, and their shoulders are usually narrower. When drawing the construction skeleton, it can be helpful to keep this in mind and aim for the hips to be at least as wide as the shoulders.

2 BLOCK IN ROUGH ANATOMY

Don't be afraid of working with curves! Female figures tend to look more voluptuous, and while not all women are curvy, it can be a great accentuation to femininity to use them to your advantage.

3 REFINE AND DETAIL

When drawing the final details of anatomy on the female body, think "less is more." Too many lines and indications of muscle definition will make the body look hard and more masculine. This can, of course, be useful for certain character types, but for a soft and feminine look, keep it simple!

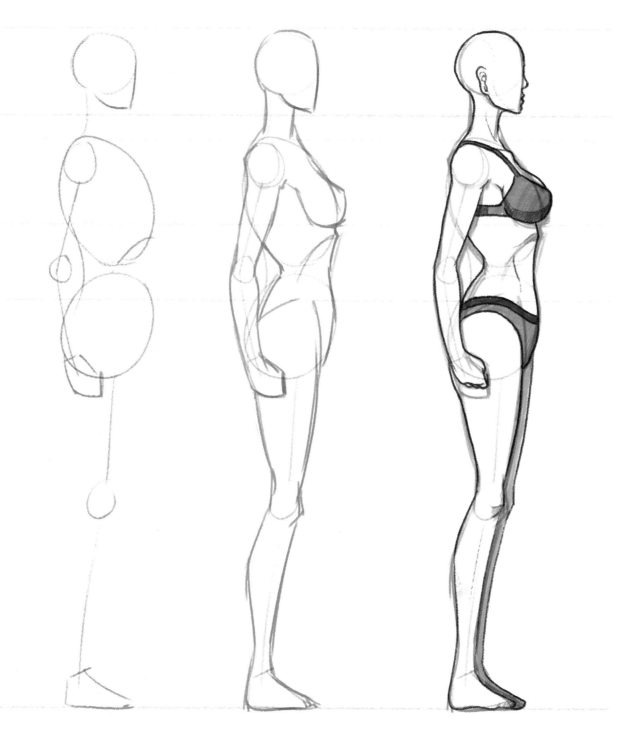

1 CREATE THE SKELETON

A strong posture is characterized by an upright head, arched back and straight legs (as we touched on previously with the male poses).

2 BLOCK IN ROUGH ANATOMY

When adding mass to the skeleton of the female figure, everything should be reasonably proportioned. If you're creating a female with large breasts and backside, the rest of her body would not logically be ultra-thin. If the aforementioned areas are drawn larger than average, so should her upper arms, thighs and waist.

3 REFINE AND DETAIL

A popular way of creating femininity in a pose is by noticeably arching the back. This makes the chest and backside stick out more and enhances the appearance of confidence and attractiveness.

Arching the Back

Slightly (or extremely) arching the back of a female character will do a few things. It will make them look more confident, and it will bring prominence to the chest, abdomen and backside. Obviously, this would look ridiculous if applied to all of your females, but in certain situations, it may be a useful aesthetic tool.

Women Have Curves

Don't be scared to make a woman curvy! Rounded shapes, particularly for the chest, hips and thighs, are a simple and effective way to add a hint of dynamism to a female character, or even add a maternal, motherly look.

Body Shape

The body shape of females, compared with that of males, has some important differences. Women typically have thinner waists, are usually drawn with wider hips and, of course, have breasts. These three factors combined are the reason the hourglass figure is used heavily in comic books and cartoons; it is an accentuated and stereotypical feminine look.

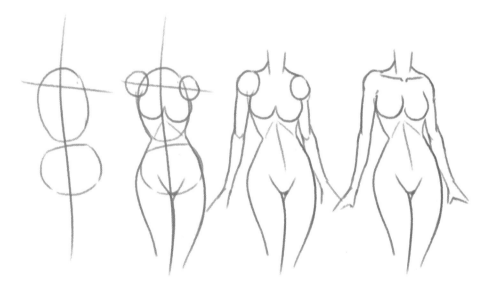

Necessary Anatomy

Breasts are often a difficult thing to draw well. It may sound odd to recommend that artists familiarize themselves with this part of the female form, but being shy about drawing a prevalent piece of anatomy will not improve your abilities. Life drawing is a great way to see how the female form can be interpreted.

PRACTICE POSES USING CONSTRUCTION LINES

Drawing dynamic poses becomes a much simpler process when using construction lines. The sketch acts as a taste test so we can see if we like the direction we're going in before we commit to the whole meal, as it were. It's normal to attempt to draw a character in one difficult pose many times until you're happy with how it's developing.

Furthermore, your construction work will improve with time and practice, as will your ability to spot what is and isn't working. Work with your figure to produce strong silhouettes that communicate the intention and motion of your characters.

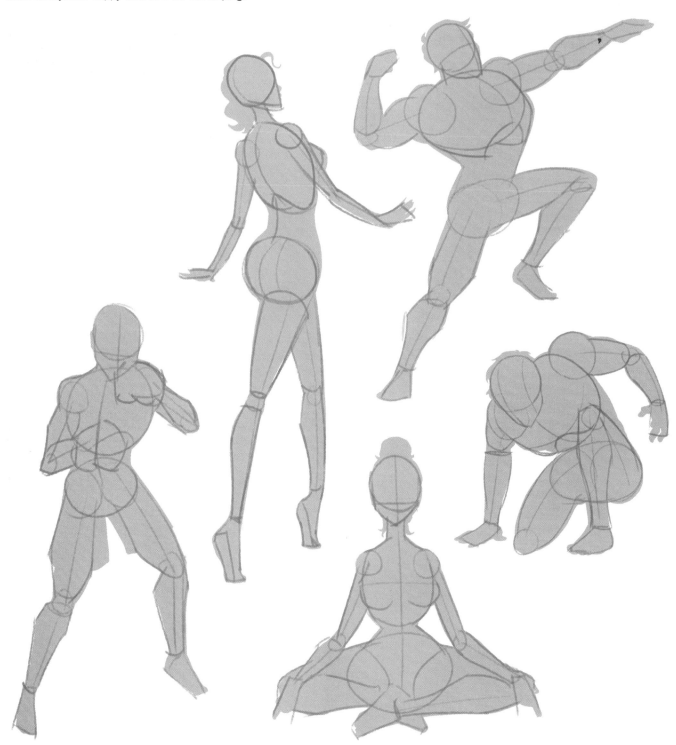

ALL SHAPES AND SIZES

As with the head, once you've learned how to draw the human form with construction lines, you can free yourself up and be creative with how you warp and play with these shapes! Play with the proportions, push yourself outside of your comfort zone and create as many interesting body types as possible! You can also use reference images or models to deconstruct different body types, which you can then recreate in various poses using simple construction lines. One of the most valuable things about construction lines is that they free you up to be more creative with less effort!

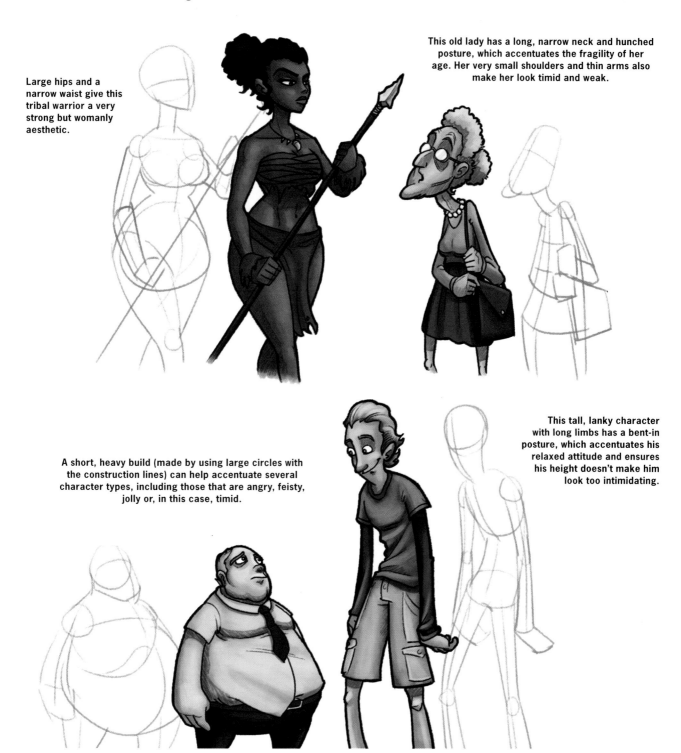

Large hips and a narrow waist give this tribal warrior a very strong but womanly aesthetic.

This old lady has a long, narrow neck and hunched posture, which accentuates the fragility of her age. Her very small shoulders and thin arms also make her look timid and weak.

A short, heavy build (made by using large circles with the construction lines) can help accentuate several character types, including those that are angry, feisty, jolly or, in this case, timid.

This tall, lanky character with long limbs has a bent-in posture, which accentuates his relaxed attitude and ensures his height doesn't make him look too intimidating.

People come in all shapes and sizes. While it's good to learn how to draw an average adult, learning how to draw characters of all ages and sizes effectively can be a useful skill for character design.

YOUNG

Children and babies have larger heads in proportion to their bodies compared to a fully grown adult, so keep that in mind when drawing children and feel free to utilize it as a feature to accentuate the childlike look. Children's limbs are also a little chubbier when they are very young (babies and toddlers), and, as they become teenagers, their proportions start moving closer to those of an adult. Giving a child a slight potbelly will also make them look cute and reinforce a cheerful and innocent look.

Here are some helpful tricks you can use to create extra-cute kids:

- Make the eyes bigger, round and shiny.

- Draw their foreheads large.

- Keep the chin and jaw soft and curvy.

- Make their cheeks nice and plump.

- Add a hint of a blush to the cheeks and nose.

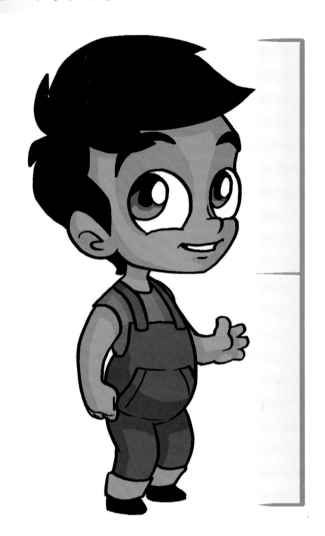

1 BASIC SKELETON

The fundamental shapes and guidelines are used for the head, torso and limbs to create a pose fitting the character. Note how large the head is in proportion to the body.

2 CORE CONSTRUCTION

Thickness is added to the character's limbs and details are constructed for the facial features and other aspects (clothing, hair, etc.). A child's arms and legs look cutest when they're soft and don't have much detail, taper at the wrists and ankles, and have fairly small, chubby feet and hands.

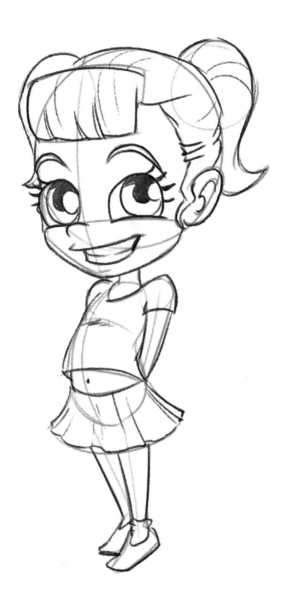

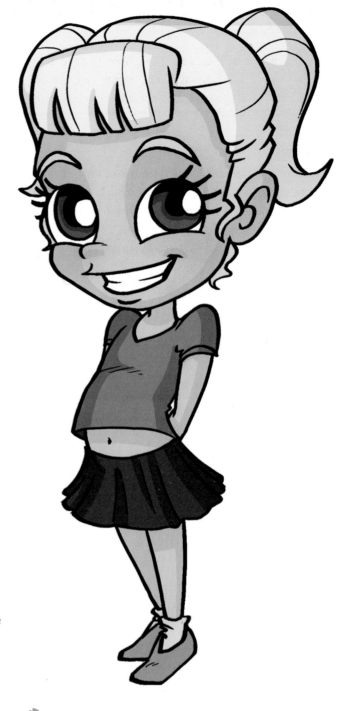

3 DETAIL AND REFINEMENT

Thicker lines in greater volume are used in areas where the most attention is desired. In this case, these areas are the eyes and hair. For the rest of the body, lines are kept simple with a focus on the character's silhouette.

4 POLISH

When your character is drawn and details have been added, you can go even further and add ink or digital lines and color to make your character stand out. This character has been colored with pinks and purples to create a stereotypical little girl aesthetic.

TEEN

Drawing teenagers entails an approach that's similar to drawing adults, especially as they reach their late teens; however, there are some key aspects you can keep in mind to visually reinforce their adolescence:

- Keep the face soft compared to an adult's.
- Give teenagers longer, thinner limbs.
- Draw them with less confident poses and expressions.

Remember, when drawing teens, style is key! Often, teenagers want to impress their friends or fit into a social group, and as such, will make more modern, fashionable, risky or sloppy clothing choices than adults. It's also useful to use props to reinforce their youth. For example, modern teenagers can often be seen with a smartphone in hand, or wearing a cap or backpack.

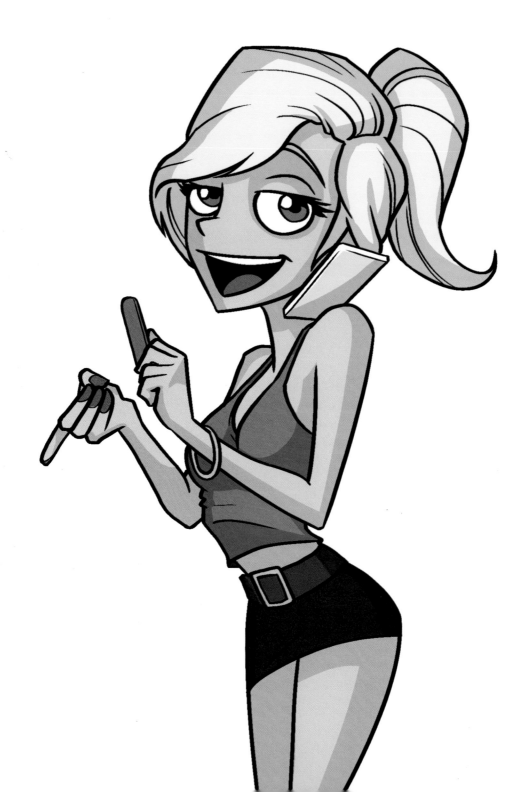

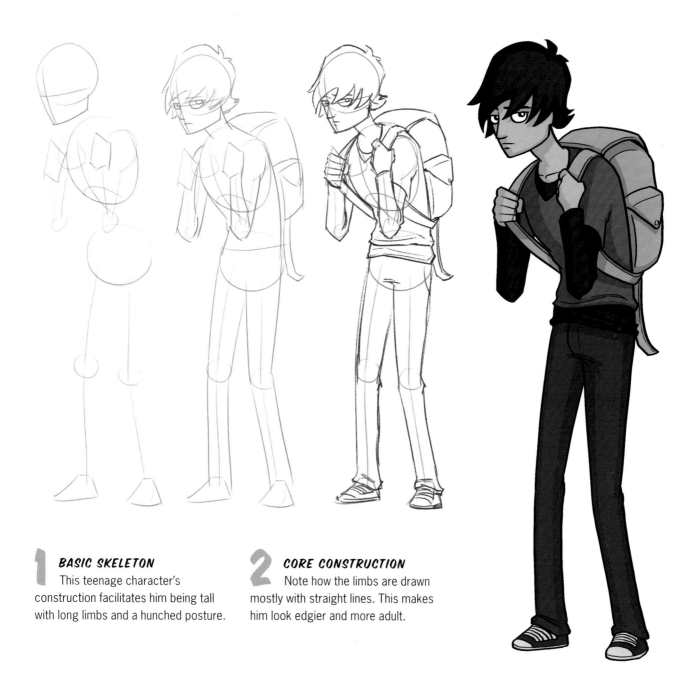

1 BASIC SKELETON

This teenage character's construction facilitates him being tall with long limbs and a hunched posture.

2 CORE CONSTRUCTION

Note how the limbs are drawn mostly with straight lines. This makes him look edgier and more adult.

3 DETAIL AND REFINEMENT

Keeping the face thin and drawing it with solid, sharp lines makes him look young but not childlike. Note that there are very few lines in the details of the face, as that would make him look older.

4 POLISH

This teenage character isn't too detailed, but his visual style is accentuated with strong colors like dark black hair and dark clothing. Combined with his hunched posture and long scruffy hair, we've created the depiction of a character who doesn't want too much attention.

OLD

Old age results in changes in the physical body, and the older someone is, the more this is apparent. Here are some common elements you can include when drawing old people:

- Hunched postures and weak-looking limbs
- Gray or white hair
- Wrinkling skin, particularly in the face, neck and hands

Wrinkled Skin

Wrinkling skin can be particularly tricky to draw well if you aren't sure where to put the details. Wrinkles are the result of the skin losing its elasticity. A helpful way to think about wrinkles when drawing them is to imagine the skin as having been stretched out over time. The skin would hang slightly from the skull and bunch up in some areas more than others. These are some of the most common wrinkle areas:

- Under and around the eyes
- At the sides of the mouth from the nose down toward the jaw
- The neck

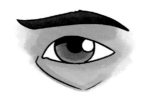

Elderly Eyes

The eyes of older people often look narrower due to the loose skin that hangs down slightly over the eyelids. Wrinkles around the eyes appear most readily in a few key areas:

- The bags under the eyes
- The crow's-feet emerging from the corners of the eyes
- Wrinkles between the eyebrows and on the brows

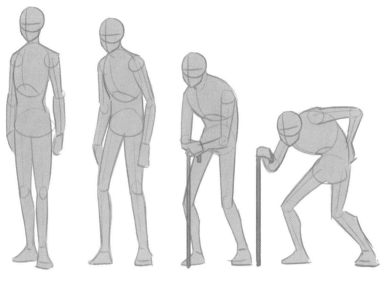

Stage 1 Stage 2 Stage 3 Stage 4

Stages of Aging in Posture

Stage 1:
Upright and healthy with no signs of the body weakening.

Stage 2:
Starting to hunch with slightly wider legs.

Stage 3:
Arched back and very bent legs. The body usually needs support at this point, typically in the form of a cane or a walker.

Stage 4:
This is an extreme version of stage 3, with the back's arch and bent legs being exaggerated. It's a bit unrealistic, but sometimes useful for more comedic aged characters.

Stages of Aging in Skin

Stage 1, Middle Aged (50–60 years): The skin starts to show more lines as it slowly loses elasticity. This generally begins to happen around the eyes, forehead and at the sides of the mouth.

Stage 2, Retirement Age (60–80 years): Males often (though not always) are balding. The skin starts to show more lines in more places, but they're still most heavily concentrated in the bags under the eyes, on the forehead and beside the mouth.

Stage 3, Old Age (80+ years):
The skin usually looks more leathery over all, with deeper lines under the cheek bones, under the eyes and on the forehead. The skin can also develop age spots.

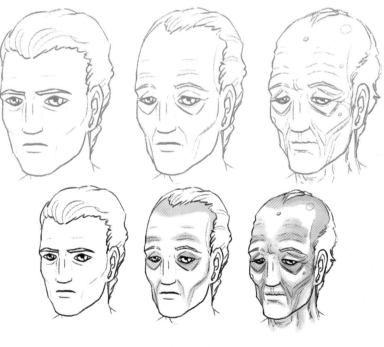

Stage 1 Stage 2 Stage 3

FAT

When someone is overweight, fat builds up more prominently in a few common areas:

* The chest and breasts

* The midriff of the torso, particularly the belly and hips

* The upper arms and thighs

The rest of the body also carries extra fat and grows in size, but the three areas mentioned above are useful to keep in mind as areas to accentuate when drawing people carrying extra weight. Keep in mind that the way body fat is carried will be different from person to person, and the way the fat sits on the body can vary, too.

When someone is significantly heavier, the fat throughout their body gathers and hangs down, causing the weight to pull against the skin. This weight tends to cause the most overlap with other body parts in the three points listed previously.

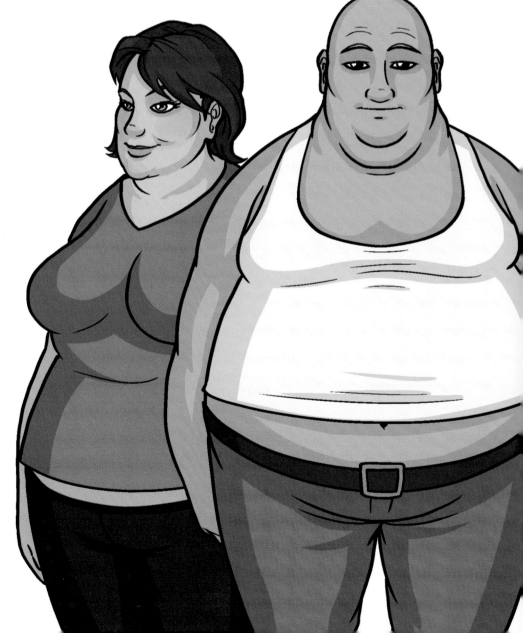

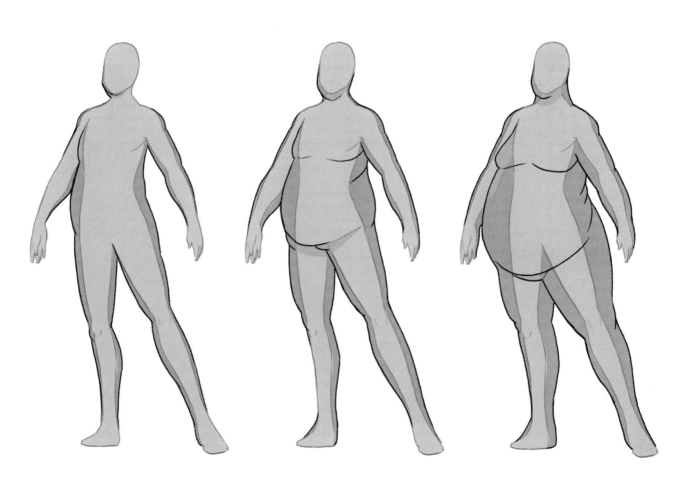

Chubby

This is a body shape you would describe as stocky or plump. A little extra weight can often be an appealing design feature to use on characters you want to look approachable or cuddly.

Overweight

At this point, the midriff of the body is significantly wider than the shoulders. The body begins to look more unhealthy than cuddly. You can also see the increase in weight along the neck as fat gathers around the jawline.

Obese

Though this is an extreme body type, it isn't necessarily a bad trait to use when designing characters. It can make a character memorable or easy to identify, and in cartoons, it can be comical or appealing (think Santa Claus). It can also be used to create unappealing characters and villains who look greedy or grotesque.

Adding Weight

Fat sits on the body like padding between the core of the body (bones, muscles, etc.) and the skin. Everyone's body will hold on to body fat in different ways, but the common areas of build-up are the midriff, upper arms, upper legs and butt, and under the jaw line around the neck.

When putting weight on a character, use the same core skeleton you would use for an average physique, then widen the areas where the weight sits on the body.

THIN

There are two ways to approach drawing thin people. One is to simply draw them as skinnier than the average person. The other is to show the forms underneath (allusions to muscle or bone), which results in an emaciated look.

When drawing in details of anatomy to show someone as extra thin, there are some places where the skin will show the bone shapes underneath, and some areas where the skin will wrap around muscle.

Bone

- The rib cage, particularly at the bottom

- The collarbone

- The hip bone

Muscle

- Abdomen

- Shoulders and arms

- Calves

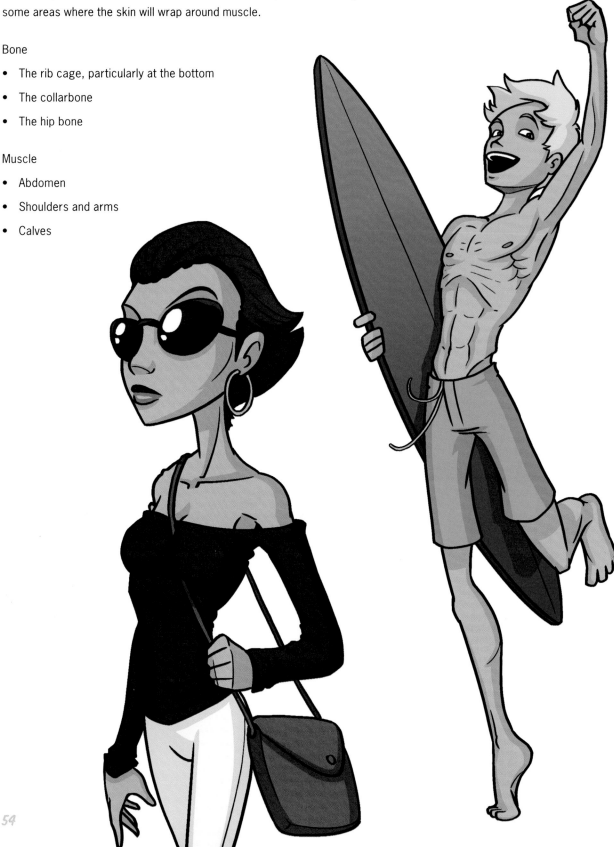

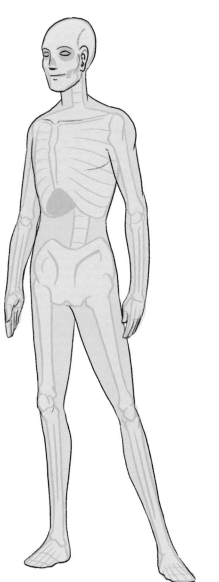

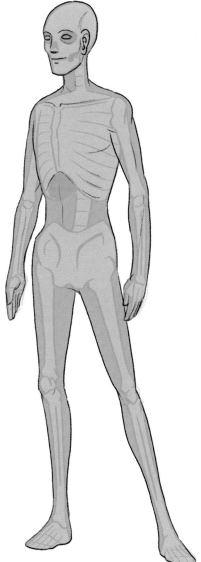

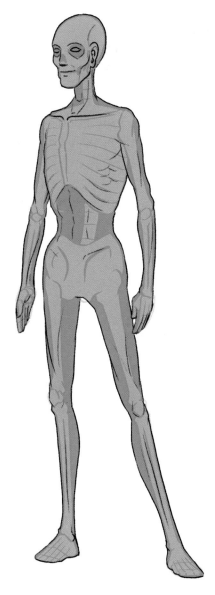

Slim

The character's shape is still soft and healthy, but there is little apparent body fat.

Skinny

The details of the muscles and bones underneath the skin begin to show. The character starts to look more fragile.

Emaciated

This is an extreme body type that shows much more of the skeleton underneath. In reality, people very rarely have *no* body fat. That said, this is a useful body type to use when emphasizing frailty to the extreme, or for creepy characters or creatures (think Gollum from *The Lord of the Rings*).

Reducing Weight

Imagine the character's skin as a vacuum-sealed bag. When the air is taken out (or, in this case, the body fat), the shape of the bag wraps tightly around its contents (in this case, the muscles and bones). Admittedly, this may not be the prettiest example, but the point is that, when there's little to no fat on a human body, the skin will show the shapes of the muscles (particularly in the arms, legs and abdominals) and bones (particularly the rib cage, hips and collarbone) underneath.

MUSCULAR

We won't go into the details of how to draw muscular anatomy. It's the kind of topic we could easily spend an entire book on, but then we'd miss out on all the fun character design stuff! That being said, once you have a basic under-standing of human muscular structure from your own studies and practice, here are some helpful tips you can keep in mind when drawing muscular characters:

- A character can be muscular without having an incredibly defined body. If a muscular character has that ripped look where you can see lots of muscular details and veins under the skin, it's the result of the character having very little body fat.

- When adding size to a muscular build to make a character look buff, think of the areas of muscle in three levels of priority, with the highest priority being the first places you add muscle mass to achieve the buff look:

 Priority 1: The chest, shoulders and back

 Priority 2: Biceps, triceps and upper legs (quads)

 Priority 3: The rest! Abdomen, neck, forearms, calves, glutes, etc.

- Muscles drawn with soft lines will look soft. To make them tough, use blockier shapes.

- To make someone look ripped, sketch a few lines following the direction of the muscle, and in the middle and dividing areas between muscles. This will make the muscles look like they're incredibly tense and about to burst with energy!

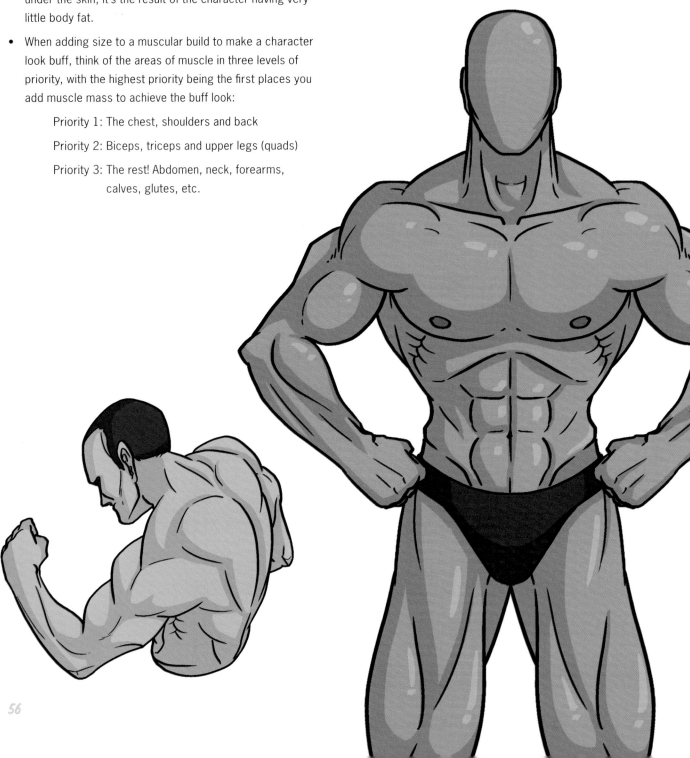

BROAD

The broad look is the result of a larger-than-average muscle mass or bone structure, along with a reasonable share of body fat. The broad character looks neither fat nor overly muscular, just big and powerful! This build is good for bouncers, bodyguards, soldiers, lumberjacks, etc. Common traits of a broad character include the following:

- A strong jaw line—makes the character look solid

- A thick brow—makes a character look very serious

- A small cranium—if you want the character to look small-brained

- Large hands and feet—make the character look powerful

- A thick midriff—makes the character appear solid to the core

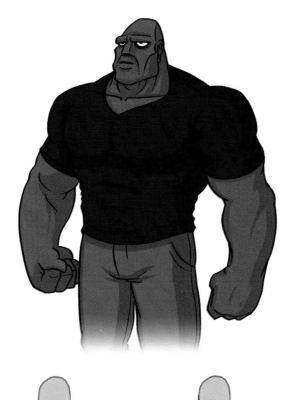

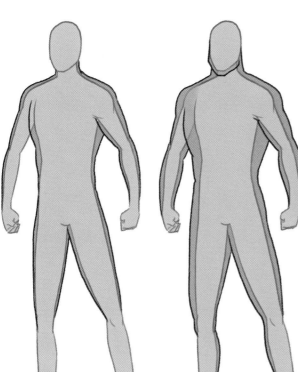

Key Areas of Mass

When creating a character who is broader and burly, thicken the body overall but make sure a few key areas are particularly beefy, such as the shoulders, chest and midriff.

CUTE

A character who looks cute will most often share the same traits as children. This is because cute things tend to look vulnerable, young and innocent.

- Large head compared to the body

- Large forehead compared to the jaw and chin

- Large, round eyes

- Small nose

Cute characters can also benefit from being drawn with small hands and feet, chubby tummies, thin necks and so on. It should be said that not all of the attributes mentioned are necessary to make a character look cute, but they do tend to be popular and generally work well. It's also worth noting that too much detail in illustrations of cute characters can be distracting and detract from the effect.

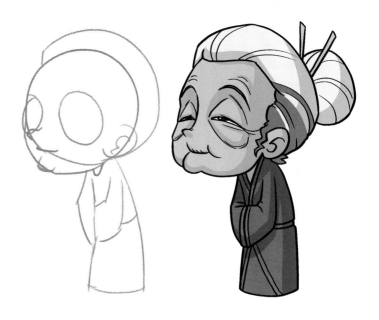

Anyone Can Be Cute

Cute characters aren't always young characters, but the traits that make young characters cute (large heads and eyes, small hands and mouths) can be applied to adults, animals or elderly people to give them that cute appeal. A style that uses cute elements for many types of characters is the *chibi* style in manga and anime.

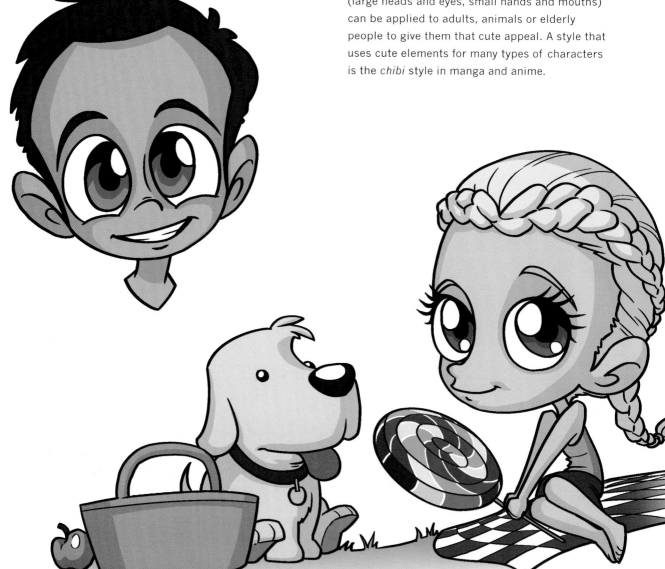

REPULSIVE

Designing ugly or weird-looking characters can be just as much fun as designing cool characters or heroes (sometimes even more fun!). The key to creating effectively freaky characters is to tweak their features until they look slightly abnormal. You want the viewer to feel like there's something off about them. Here are a few ideas:

- Eyes that are too far apart or too close together

- Teeth that are too small with extra gums showing

- An extremely skinny character with a potbelly and an awkward pose

- Very small pupils, or pupils that are looking slightly cross-eyed or are too far apart from each other

- A warped design feature, such as a fat, crooked nose, long pointy chin, flappy ears or tiny hands and feet

There are countless ways you can design repulsive characters, but keep in mind that, even though we're intentionally designing them to look unconventional, they will still need a certain level of appeal so your audience can enjoy watching them. I recommend applying one or two malformations to act as featured elements of their uncanny design and keeping the rest at least moderately average.

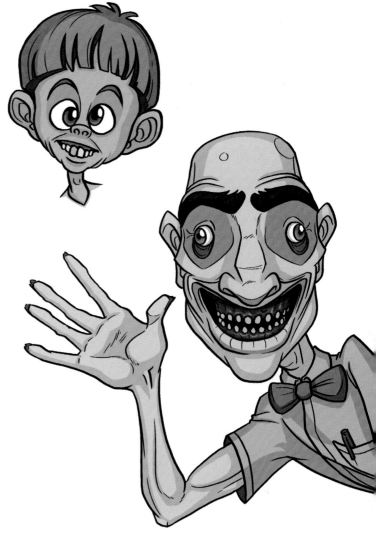

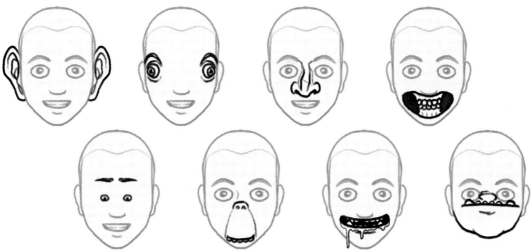

Alter One Feature

Sometimes all it takes to make a character repulsive is taking one feature of the face and making it look wrong. This can be done by making it too big, too small, warping the proportions and position of it relative to the other facial features, or emphasizing asymmetry. Here are eight faces that share the same foundation, but each has one specific feature that has been warped to make the character more repulsive.

BRAINSTORM SKETCHING

The first design you sketch on paper won't necessarily be the best. Sometimes we have a clear idea in our head of what our character design should look like, and we end up quickly settling with one of our first few ideas without much exploration. The remedy for this kind of closed-minded thinking is open-minded sketching! I call this brainstorm sketching.

Brainstorm sketching involves creating a rough sketch of the first few designs that come to mind and slowly exploring other styles and attributes. Push yourself to think outside the box and try things, whether you think they'll work well or not. In fact, it can be a healthy exercise to try things you think *won't* work, just to loosen up. You'll often discover interesting ideas for the design that you prefer. On top of this, if you're designing your own characters, you'll find that this process of brainstorm sketching will also help your mind play with ideas for stories, settings, other characters and more.

Let your ideas flow freely on the paper. When you have a dozen or so sketches, highlight several that stand out to you and annotate them with a few words indicating what you like about them. Repeat this process until you feel you have enough ideas to move forward.

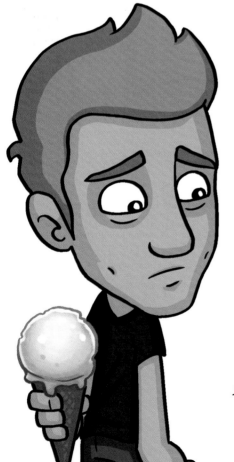

What is a Design Brief?

As we delve into the hands-on stages of the design process, we'll use design brief examples to demonstrate how various ideas or assignments can be explored visually.

The design briefs throughout this book will sometimes be presented as ideas given from a client, and sometimes as examples of concepts generated by the artist alone.

In short, a design brief is a summary of the character's design and key features to be included. For example, "a short-tempered, small monkey who likes to wear human clothes and sucks on a pacifier." A design brief should be simple enough to allow you, the designer, freedom to explore the concept while providing enough information to give you specific aspects to focus on.

WHY GO STRAIGHT FOR VANILLA WITHOUT SEEING IF YOU PREFER CARAMEL-SWIRL WITH SPRINKLES?

Explore Your Options

In the brainstorm sketch session shown here, I sought to create a scientist character without a design brief or a specific direction. By keeping my ideas open and my sketching loose and relaxed, I ended up with a wide array of visual ideas, three of which stood out as great starting points to explore further.

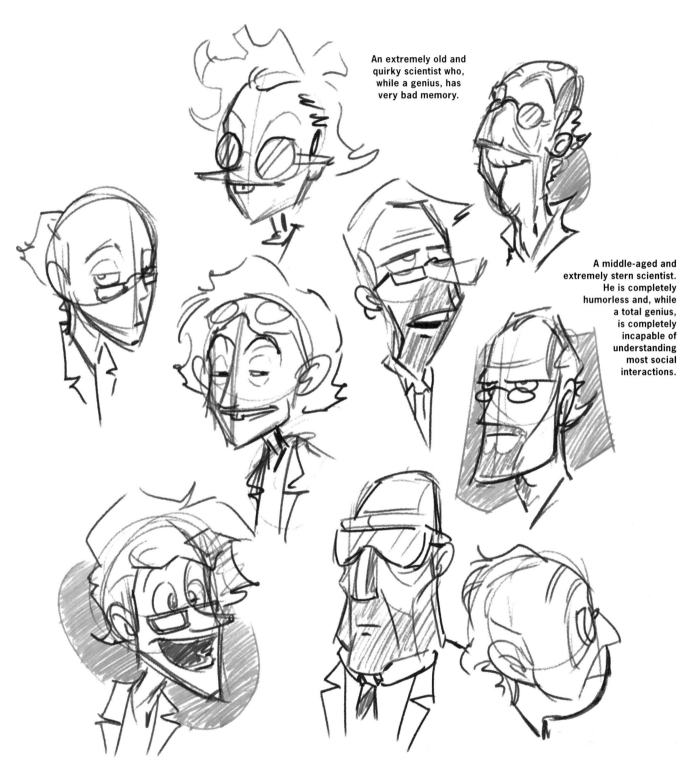

An extremely old and quirky scientist who, while a genius, has very bad memory.

A middle-aged and extremely stern scientist. He is completely humorless and, while a total genius, is completely incapable of understanding most social interactions.

An adolescent super-genius who is not taken seriously by his peers or the girl he has a crush on. He is ever optimistic and unwilling to give up!

Design Brief

A small bakery wants a cartoon character of a female baker with a traditional hat. They want something sleek, professional and friendly.

Simple Can Be Memorable

While playing with this character design, I experimented with a mix of the super-simple and stylish cartoon styles. Most of the preferred outcomes were visually simple and flat, but they proved to be more memorable as a result.

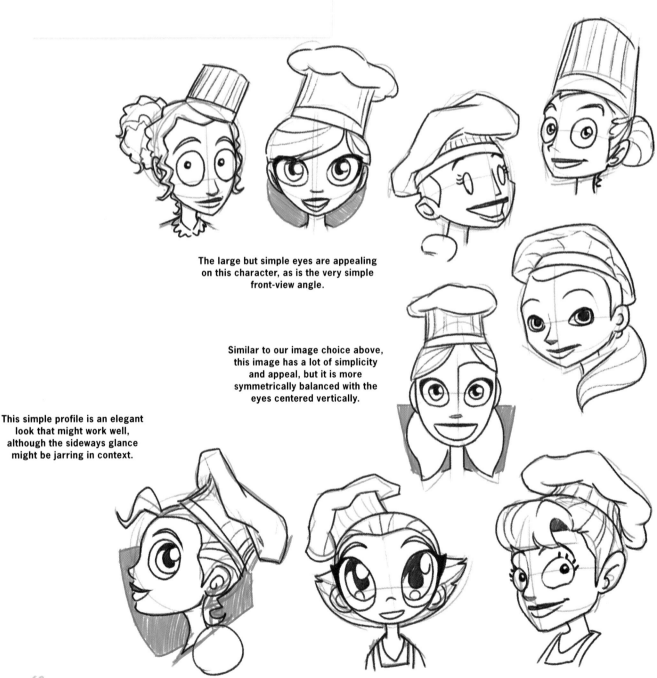

The large but simple eyes are appealing on this character, as is the very simple front-view angle.

Similar to our image choice above, this image has a lot of simplicity and appeal, but it is more symmetrically balanced with the eyes centered vertically.

This simple profile is an elegant look that might work well, although the sideways glance might be jarring in context.

NEXT STEPS

Try to recognize when it's time to move from the design stage to the next stage (develop). For me it's a feeling of satisfaction and excitement. It's the feeling that the designs you have in front of you are close, or perhaps even perfect! But remember that this is a raw feeling, and your designs are raw designs. If you're someone who has trouble liking your own work, don't let your lack of confidence paralyze you. You don't want to get stuck in this stage of the process.

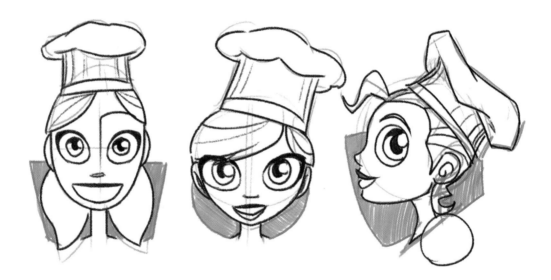

Narrow Down and Move Forward

The next step involves taking these few raw designs, testing them in context and narrowing down the aspects that work before refining and polishing the art.

BRAINSTORM SKETCHING: PILOT

Design Brief

Design the protagonist of an action/adventure video game. The character is a military pilot who has crash-landed in the middle of enemy territory. The character's style is based on a US WWII aesthetic with stylistic exaggeration.

Face Choices Made

Let's say that, as the result of some playing around, the faces shown above are your favorite picks so far. Next, start playing with the body and clothing. It's usually good to start off with a character's head and face first since they're typically the most memorable part of a character.

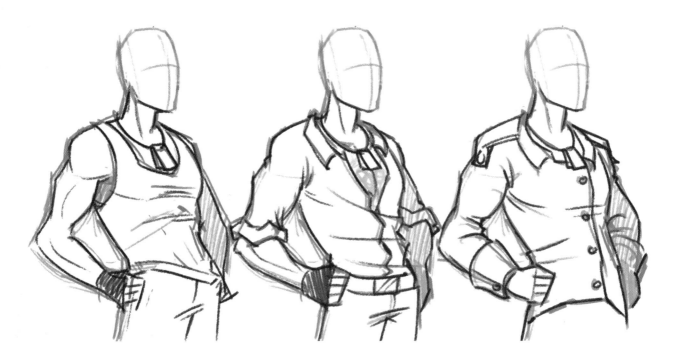

Mix and Match

Experiment with the body on its own, at first, to find the features and styles that work well with the direction you're going in. In this case, the things I want to keep or experiment further with are the dog tags, belt, gloves and tank top *or* an official-looking jacket, cargo pants, etc.

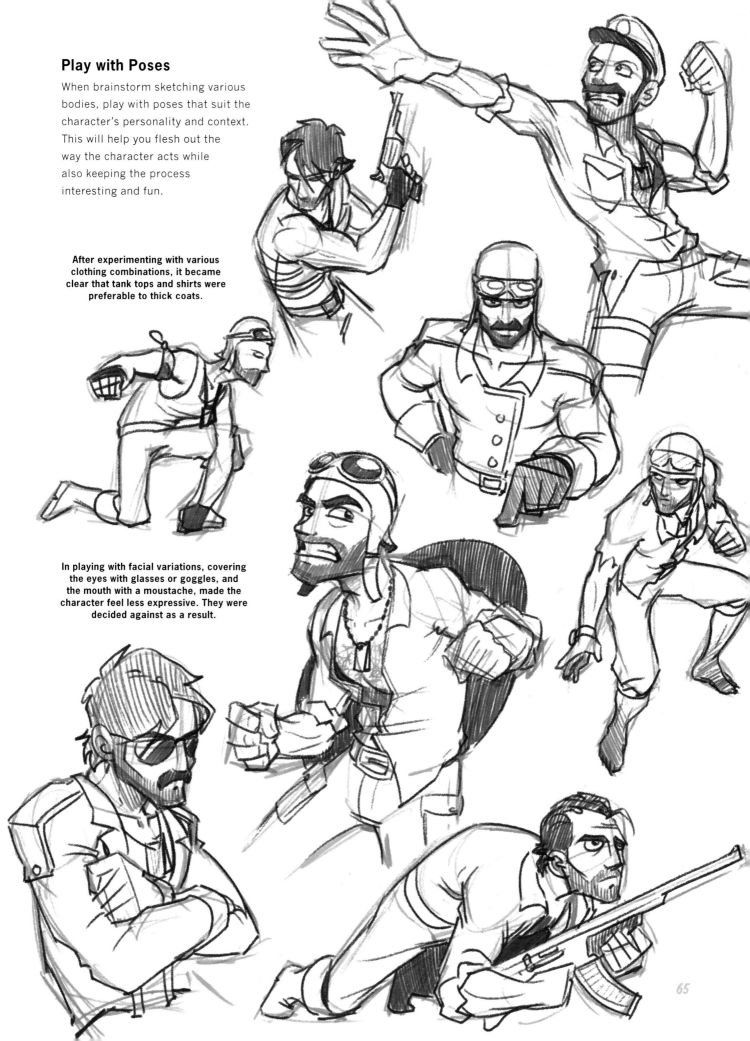

Play with Poses

When brainstorm sketching various bodies, play with poses that suit the character's personality and context. This will help you flesh out the way the character acts while also keeping the process interesting and fun.

After experimenting with various clothing combinations, it became clear that tank tops and shirts were preferable to thick coats.

In playing with facial variations, covering the eyes with glasses or goggles, and the mouth with a moustache, made the character feel less expressive. They were decided against as a result.

65

Keep Practicing

Keep in mind that, as you learn and grow as an artist, your instincts will improve. People tend to think that it's solely your drawing skill that gets better when you practice, but that's not true! Not only will your drawing skills improve, but so will your eye, your instincts and your workflow. Don't get frustrated if you feel stuck or like you're not progressing. Improvement always comes with time and practice!

Full-Body Pose Brainstorming

Approach full-body brainstorming with the same relaxed and open-minded approach we used for drawing heads and faces. A character's costume and body is as important to a design as the character's face. Work with one to two more prominent design features for each sketch, and try everything that comes to mind. Then, highlight a couple of designs you like and note a few words indicating why.

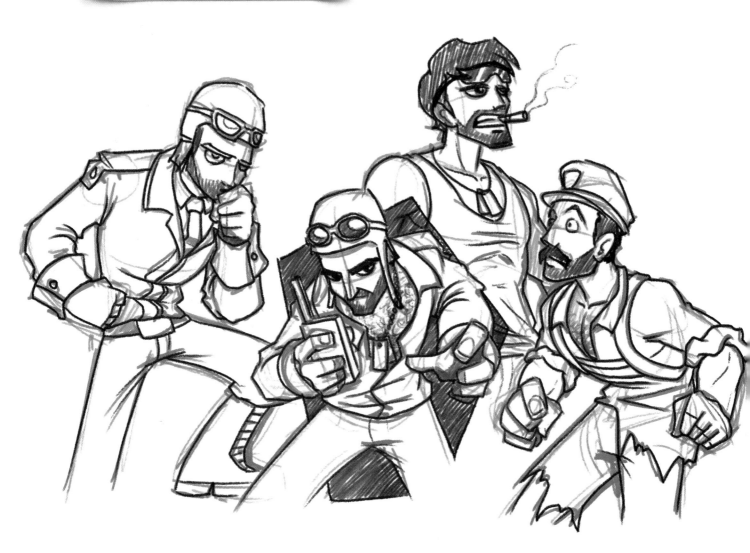

STAGE 3
DEVELOP

During the design stage, you will have discovered that there are some images or design aspects that just seem to stick. It might be a hairstyle, a feature like glasses or a tattoo, or even something unusual, like the absence of a nose or an extralong neck. If something seems to be working, the development stage is the time to see if it's worth keeping. It's also a great time to mix and match some of these ideas. Something that looks great on its own may not look as good in combination with other design elements that seem to work well.

Keep in mind that you don't need to be 100 percent settled on a single design. We're still playing with various elements, but by this stage we have a clearer idea of what works and what doesn't.

As we begin to clean everything up in both our drawings and our approach, we slow down a bit, take the time to give our sketches a feeling of finality and produce finished drawings.

Here are a few of the things we'll do during the development stage:

- Choose and refine features.
- Consider color schemes.
- Develop settings.
- Test characters in context.

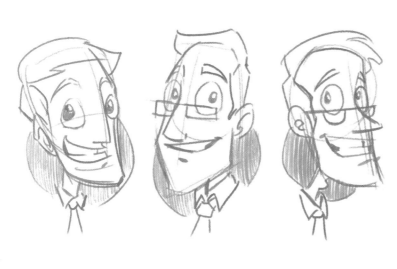
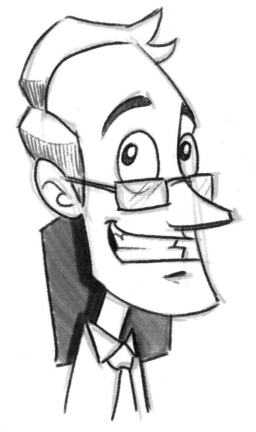

Refine Your Character

During the development stage, we take the options we liked from the design stage and continue working with them until we get a final result we like.

NARROW IT DOWN

When entering the development stage of the design process, you should have around two to five designs that you like. Now it's time to start being picky and selecting the best designs and features. Narrow down the selection until you're left with a final design.

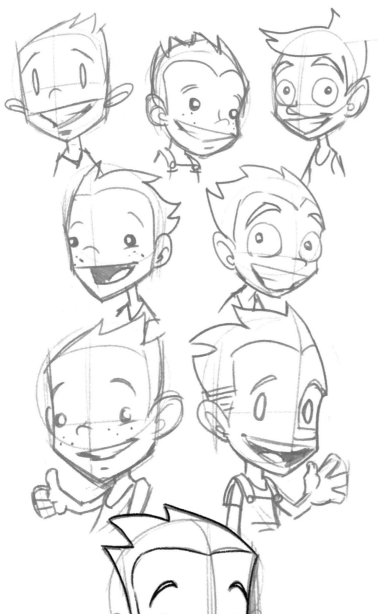

Preliminary Designs: Begin with a wide range of ideas using a simple cartoon style, just to see what works.

Early Refinement: Using the process of elimination, keep what works and cut what doesn't.

Further Refinement: Slowly continue to narrow down the designs as you identify what you definitely want in the final design.

Final Design: Finally, after much experimentation, you have a character design you're ready to test in context and polish into deliverables.

This process doesn't have a specific number of steps or stages. Sometimes it's a quick and easy refinement process, and other times, it takes a lot of experimentation and work. I like to take one or two of my favorite character designs and mix and match my favorite design elements, such as a hairstyle or clothing prop, and see which combination works best.

Design Brief

Create Pesty's older sister, who's always trying to foil Pesty's pranks. She is obsessed with boy bands and is a bit nerdy.

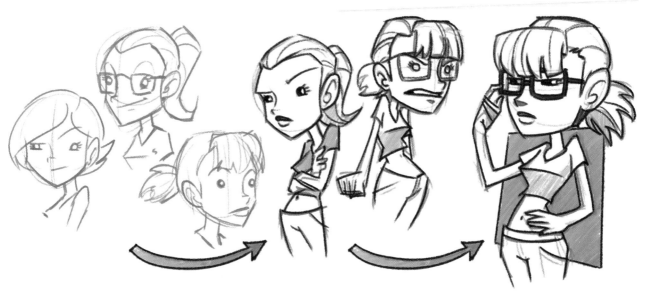

While brainstorming, you can see that tying the hair back works well with the young girl look while also appearing practical.

During refinement, decide whether she should have bangs and wear glasses, and whether her ponytail should be long or short. Otherwise, the clothes and facial features of the character are working.

The final design uses the casual look with glasses, short ponytail and bangs.

While brainstorming, you see that a longer, blockier snout feels more traditional and works better with the style of the other characters. A large nose and floppy ears add appeal.

Design Brief

Design Pesty's pet dog and accomplice. He's as small and cute as Pesty, always dirty and just as much of a troublemaker.

During refinement, decide between a scruffy look with slightly longer and messier hair, or short fur. Also experiment with varying color in the design (such as the black ears).

The final design has a scruffy look and color spots, both of which make for a more playful character design. Adding a name tag to the collar makes the dog look like he belongs to a loving home.

BODY REFINEMENT

In many cases, the best place to start with a character design is the head. But once the head is designed and you're happy with it, you still have to design the rest of the body. Fortunately, having a finalized head design to begin with can make the whole-body design easier and quicker. The process for refining a full-body design is exactly the same as the process for the head.

Design Brief

Design a female hero for a comic book set in a junkyard world where everything is made from apocalyptic trash. She is a skilled mechanic with attitude, twenty-three years old and feisty.

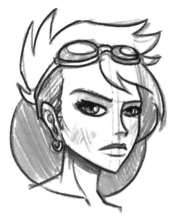

Finished Head Design

The head design is ready to go. It just needs a body!

Design and Develop the Body

Through the same process of elimination and refinement, we narrow down our options for the full-body design until we have something we're happy with.

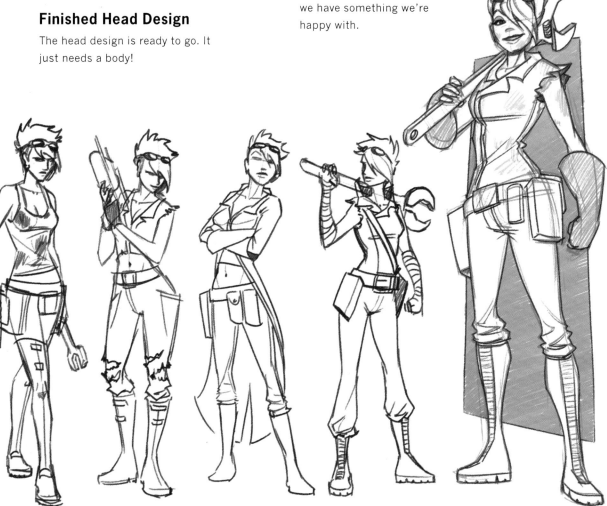

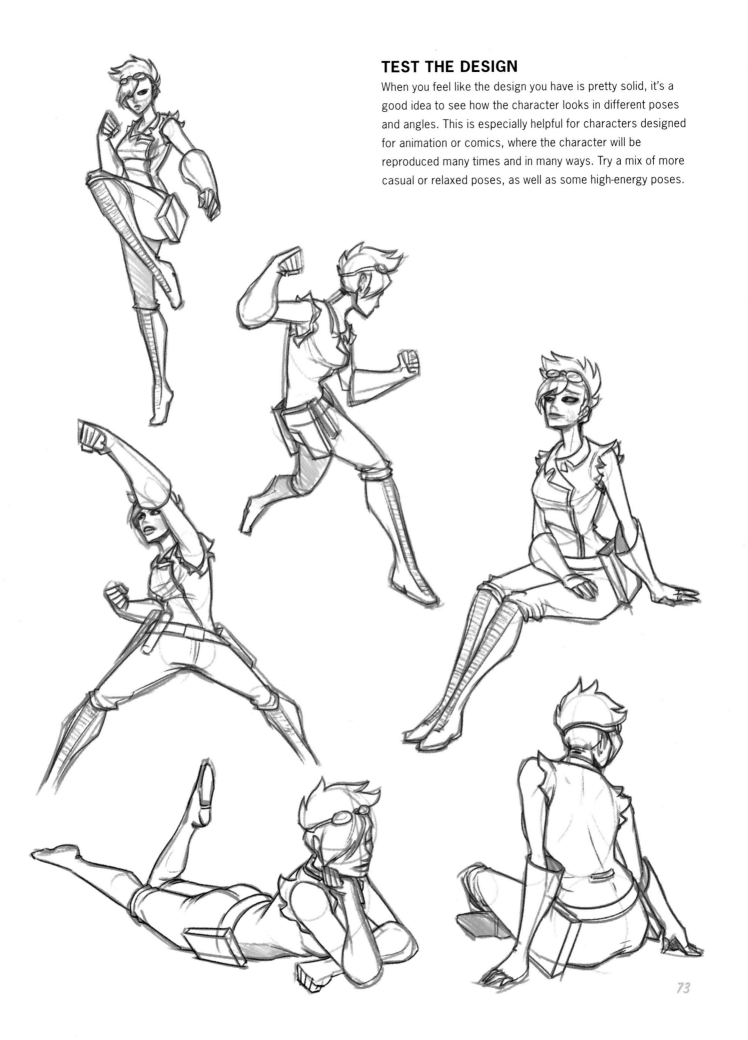

TEST THE DESIGN

When you feel like the design you have is pretty solid, it's a good idea to see how the character looks in different poses and angles. This is especially helpful for characters designed for animation or comics, where the character will be reproduced many times and in many ways. Try a mix of more casual or relaxed poses, as well as some high-energy poses.

73

WORKING WITH COLOR

Exploration and experimentation are crucial to finding the perfect design, and experimenting with color is no exception.

Color can aid the viewer's ability to categorize the characters they meet. It can communicate mood and aesthetic tone, and can make characters more recognizable and appealing. In the example below, notice how even though the character's design is identical in each variant, the color changes alone create an immediate impact on your assumptions about the character.

Test Your Colors

Test several colors on your character's clothing and props to see which one creates the right feeling and tone.

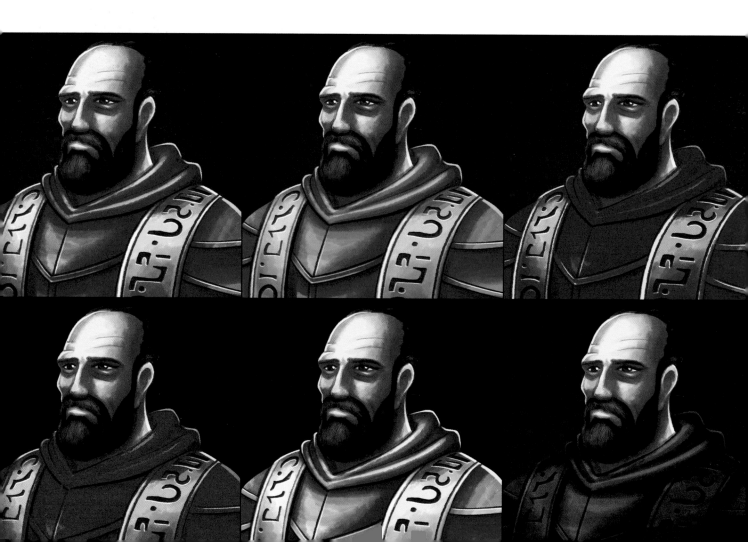

TRY THEM OUT

As has been said several times already, your first idea isn't always the best idea! When you have a finished character design and are ready to add color, try your initial ideas first, as well as a few more adventurous ones, and see if something emerges that you like. Then, using the same process of elimination and refinement, find the color combination that works for the final design.

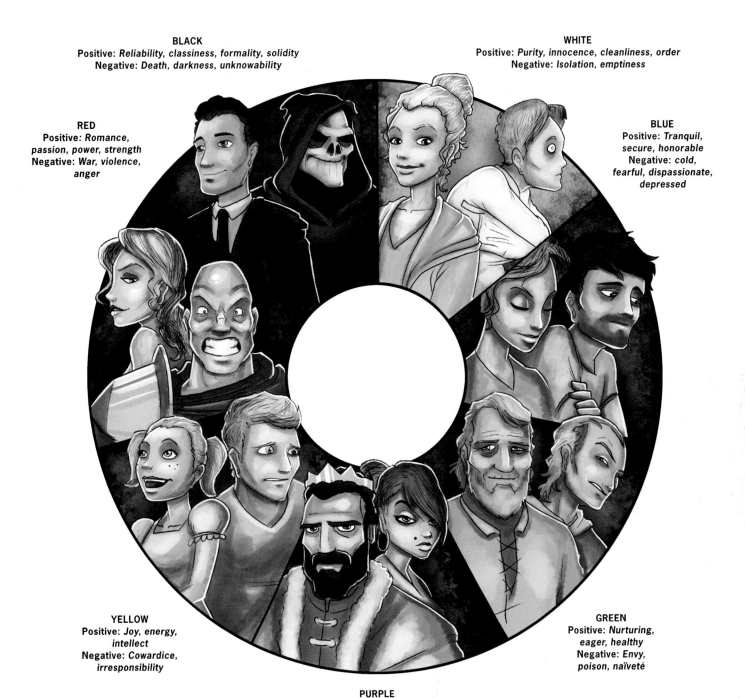

BLACK
Positive: *Reliability, classiness, formality, solidity*
Negative: *Death, darkness, unknowability*

WHITE
Positive: *Purity, innocence, cleanliness, order*
Negative: *Isolation, emptiness*

RED
Positive: *Romance, passion, power, strength*
Negative: *War, violence, anger*

BLUE
Positive: *Tranquil, secure, honorable*
Negative: *cold, fearful, dispassionate, depressed*

YELLOW
Positive: *Joy, energy, intellect*
Negative: *Cowardice, irresponsibility*

GREEN
Positive: *Nurturing, eager, healthy*
Negative: *Envy, poison, naïveté*

PURPLE
Positive: *Noble, wealthy, spiritual*
Negative: *Mysterious, moody, volatile*

Communicating with Colors

Colors have both positive and negative emotions and attributes associated with them. You can use color to accentuate a character's personality and role.

GENRE AND SETTING

Characters you design should be products of their environments and, as such, should have features that complement (or intentionally contrast with) the world in which they're placed.

The genre of the world and character can be categorized by narrative style or subject matter, such as drama, romance or action. For our purposes, however, we're going to let narrative genre and story take a backseat and look at frequently used combinations of visual and thematic elements that make up the genre of a world setting, such as steampunk, western or utopian.

In the following pages, we'll look at general outlines of specific world settings, as well as lists of people, places and things popular in each, and the commonly applied narrative genres. As you develop your characters, it may be helpful to you to come up with similar outlines and lists, and perhaps even sketch ideas relating to them. This can help improve your familiarity with a setting and help bring your characters' designs to a place that works well with the world around them.

MODERN

A modern setting will be most familiar to your audience and will need to be cleverly presented to maintain their interest. Modern settings are typically located in urban environments, but they can also be located in suburbs, rural towns or the wilderness.

Common in a Modern Setting

People: Lawyers, shoppers, professional athletes, supermarket clerks, scientists, DJs, criminals, teachers, farmers, doctors

Places: Big cities, urban ghettos, quiet towns, gated communities, isolated farmhouses, snowy chalets

Things: Cars, airplanes, credit cards, personal tech and accessories (smartphones, tablets, watches, etc.), business suits, coffee

Popular Narrative Genres: Any

Many modern props include items of technology or clothing that people use for practicality or style. They can all be broken down into simple shapes and drawn as part of the character's construction process.

Cellphones are a staple part of modern society. Smartphones are the easiest to draw because they're basically thin rectangular boxes Older phones (such as flip phones) tend to have bulkier shapes and protruding features (antennae, buttons, etc.).

MEDIEVAL

Medieval settings can range from the historic to the fantastical. Lately, it has become popular to add a touch of gritty darkness to a medieval fantasy world, but medieval settings have traditionally been filled with chivalry, color and adventure.

Common in a Medieval Setting

People: *Kings, peasants, princesses, merchants, mercenaries, thieves, wenches, knights, barkeepers, fortune tellers, servants*

Places: *Stables, feasting halls, fighting arenas, taverns, dungeons, castles, villages*

Things: *Swords, crowns, coins, livestock, dragons, campfires, ale, armor, horses*

Popular Narrative Genres: *Action, adventure, fantasy, drama, history, fairy tale, romance*

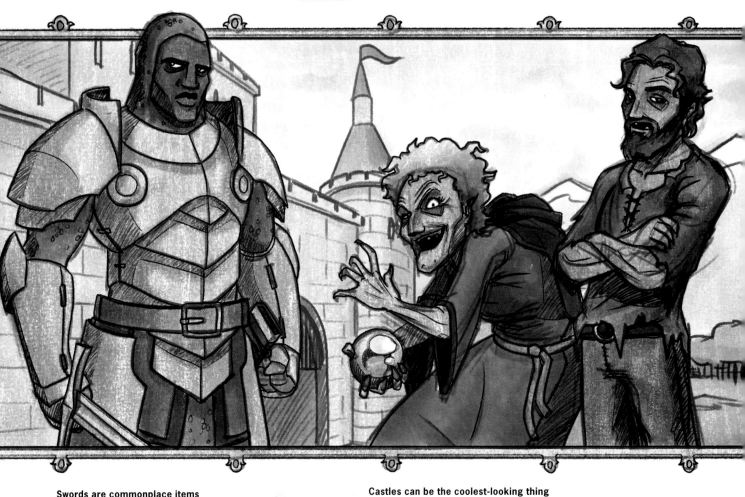

Swords are commonplace items in medieval settings. They come in many shapes and sizes, but they can all be broken down into simple shapes.

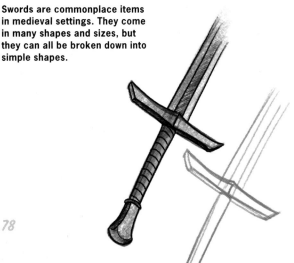

Castles can be the coolest-looking thing about a medieval setting. When drawing them, think in terms of building blocks. Towers are cylinders with cone-shaped roofs, and walls are usually tall and straight. It's helpful to look up references of historical castles when designing your own.

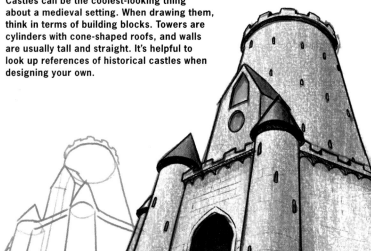

SCIENCE FICTION

Science fiction settings are futuristic and typically depict imagined future social and technological changes. Examples can range from plausible theories and concepts to the theatrical and absurd. The more fantastical science fiction settings are often referred to as space opera.

Common in a Science Fiction Setting

People: *Aliens, spaceship captains, intergalactic traders, ship pilots, exotic renegades, interplanetary ambassadors*

Places: *Spaceports, overpopulated urban cities, uninhabitable planets, intergalactic warships, unexplored star systems*

Things: *Laser guns, holograms, alien pets, strange foods, advanced technology, space suits, spaceships*

Popular Narrative Genres: *Action, adventure, thrillers, horror, fantasy, comedy*

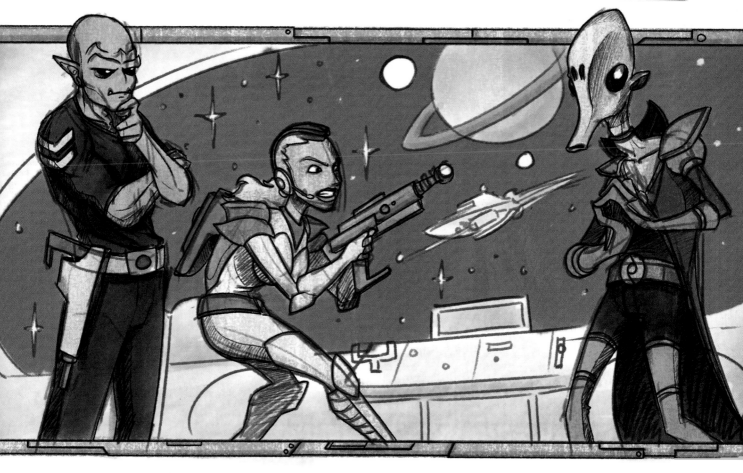

Some spaceships look clunky and rough. This look is achieved by using hard edges and combining many parts (blocks, cylinders, etc.) into an overall cohesive silhouette.

Spacesuits can be created in many different ways, but it's helpful to approach them like stylized suits of armor made up of different core pieces (the shoulders, torso, pelvis, gauntlet, etc.) Keep in mind that they need to be completely sealed from the vacuum of space; make sure there are no gaps or holes!

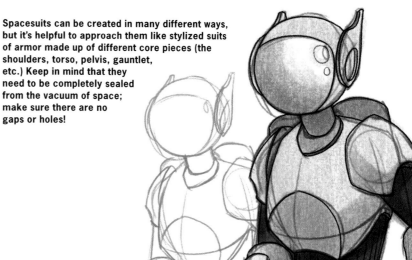

WESTERN

A typical western setting is located in colonial America and is filled with grit and adventure. The Wild West is an untamed landscape filled with all kinds of unsavory folks, such as outlaws, bandits and the occasional heroic antihero.

Common in a Western Setting

People: *Sheriffs, settlers, bandits, bartenders, Native American tribespeople, "snake oil" salesmen, poker players*

Places: *Saloons, county jails, stables, doctors' houses, bandit forts, town centers*

Things: *Showdowns at dawn, cowboy hats, guns, whips, playing cards, whiskey, corsets, cacti, trains*

Popular Narrative Genres: *Action, historical, historical fiction, romance, thriller*

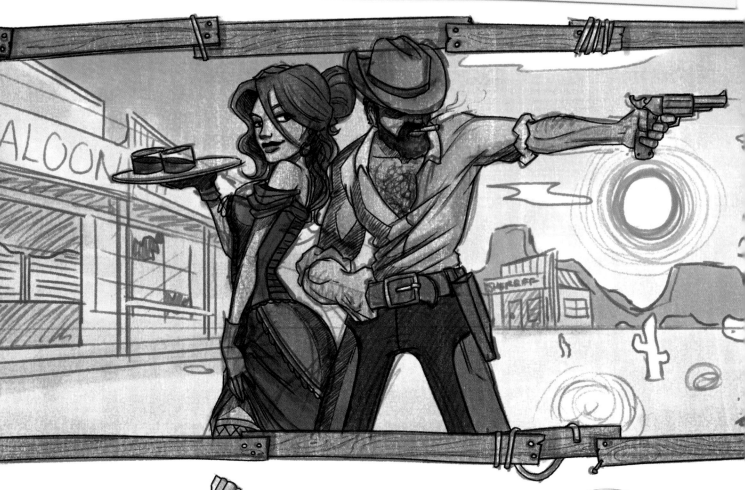

The Wild West was rife with rifles! Guns are a key visual and narrative component to most characters and stories based in this setting.

The Wild West was exactly that—wild! To communicate this, show it in how you dress your scenes and characters with props. Cards are often used because they convey a culture of gambling and risk. Whiskey is also commonly used to convey roughness and drunken behavior.

SUPERHERO

A superhero setting is usually modern, but combining it with other themes (such as science fiction) can be fun, too. Superhero characters often learn of their powers through unexpected circumstances, and they almost always receive a call to action (a situation that forces them to use their powers and become the hero). But remember that heroes tend to be more interesting if they have relatable flaws.

Common in a Superhero Setting

People: *Superheroes, brilliant tech-geniuses, commanders, supervillains, subordinates, civilians, thieves*

Places: *Secret lairs, headquarters, impressive tech facilities, towns, cities, newspaper buildings, skyscrapers, police stations*

Things: *Capes, superhero emblems, radioactive stuff, alien elements, communication devices, signal beacons*

Popular Narrative Genres: *Action, adventure, comedy, mystery, science fiction, thriller*

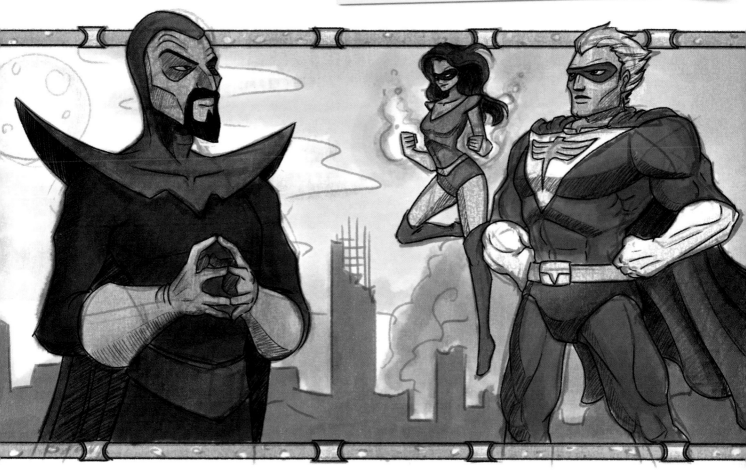

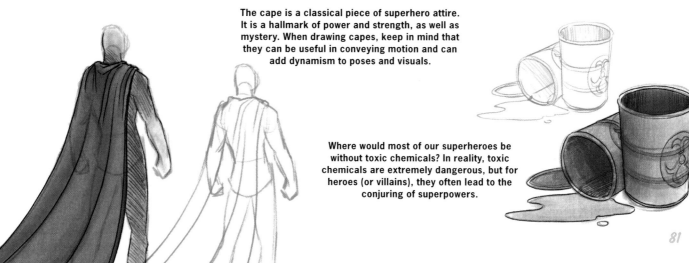

The cape is a classical piece of superhero attire. It is a hallmark of power and strength, as well as mystery. When drawing capes, keep in mind that they can be useful in conveying motion and can add dynamism to poses and visuals.

Where would most of our superheroes be without toxic chemicals? In reality, toxic chemicals are extremely dangerous, but for heroes (or villains), they often lead to the conjuring of superpowers.

DYSTOPIAN

Dystopian stories take place amongst the remnants of a once great or idealistic past, in a world that has become a terrible place. This can be literal or metaphorical, meaning a dystopian setting may involve crumbling buildings and statues surrounding the (now primitive) protagonists, or it may take place in a dystopian society ruled by a totalitarian form of government that is controlling or inhumane.

Common in a Dystopian Setting

People: *Rebel group or person, military captains, sociopathic leaders, spies and infiltrators, primitive social groups*

Places: *Government headquarters, offices of the overlord, rebel hideouts, military bases, weapon facilities, labs*

Things: *Group divisions and classifications, class warfare, genocide, highly controlled weapons, social symbols*

Popular Narrative Genres: *Action, drama, fantasy, mystery, political, romance, science fiction, thriller, urban*

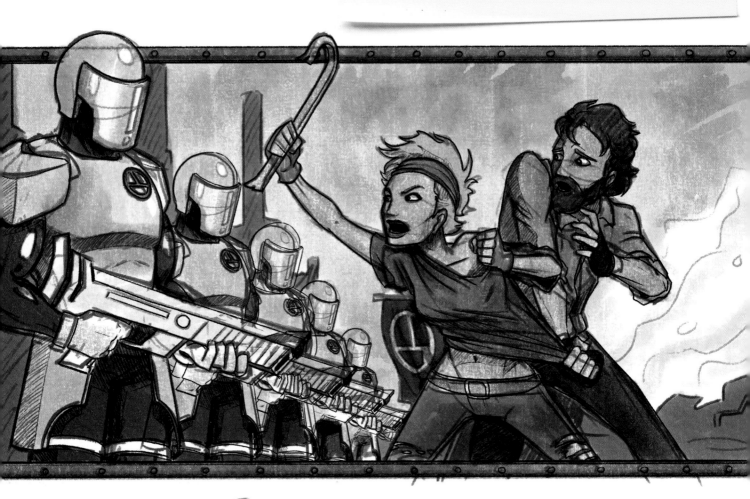

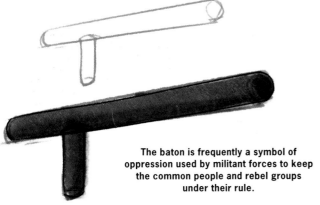

The baton is frequently a symbol of oppression used by militant forces to keep the common people and rebel groups under their rule.

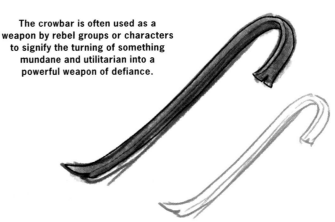

The crowbar is often used as a weapon by rebel groups or characters to signify the turning of something mundane and utilitarian into a powerful weapon of defiance.

UTOPIAN

In a utopian setting, everything is as perfect as it could be, from the people to the government to the infrastructure and so on. Often, utopian stories have a dark side or a pivotal flaw that makes the utopia illusory. Utopian aesthetics include clean lines, bright and light colors or white, sleek, shiny designs and hard edges.

Common in a Utopian Setting

People: *Overseers or rulers, advisors, medical geniuses, councillors, guards, teachers, philosophers*

Places: *Ruling headquarters, schools, military precincts, medical facilities, megacities*

Things: *High-tech communication and transportation, clean energy, sculpture and art, shiny buildings, white clothing*

Popular Narrative Genres: *Adventure, crime, mystery, political, romance, science fiction*

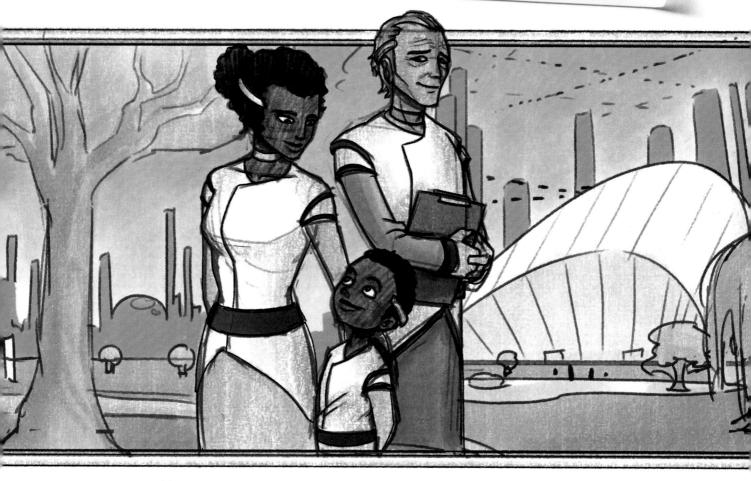

Holograms are common in futuristic utopian settings as they make us question what is real and what is possible. But most importantly, they make the audience think, "Cool! A hologram!"

Screens are everywhere in a utopia. They advertise, inform and visually enhance, but most of all, they represent the connectedness of technology with everything else in the world, and with all of the society's inhabitants.

STEAMPUNK

Steampunk stories often take place in alternative versions of history where steam power has maintained its place as a popular source of power. As such, these settings often retain stylistic elements from the Victorian era. It's a retro-futuristic genre that often includes brass, cogs and gears, pistons and intricate clothing and craftsmanship.

Common in a Steampunk Setting

People: Engineers, pilots, aristocrats, scientists, duelists, inventors, explorers, spies

Places: Megastructures, factories, steam trains, flying steam-powered ships, ghettos, mansions

Things: Cogs, gears, levers, brass, intricate machinery, goggles, steam-powered transportation, leather

Popular Narrative Genres: Action, adventure, fantasy, historical fiction, mystery, romance, science fiction, urban fantasy

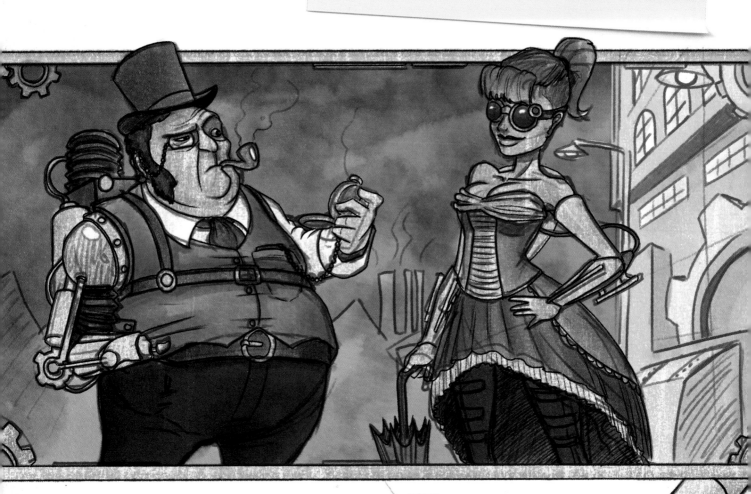

Cogs and gears, pistons, valves, rotors, chains, etc., are prevalent in the steampunk genre, whether used in cities, props or people. This genre benefits from being visually unique, and the use of these mechanical features in combination with Victorian-style clothing and craftsmanship embodies the fun and unique steampunk style that so many people love.

AND THE LIST GOES ON

The world settings I've described are only a few of the possibilities for your characters and stories. As far as character design is concerned, creating a setting and having a genre and a style can be a useful way of building a solid and cohesive look that carries across the entirety of the context in which the characters will be used.

You can also mix and match settings, which is a fun way to grab people's attention while also giving you the opportunity to create unique and clever character designs.

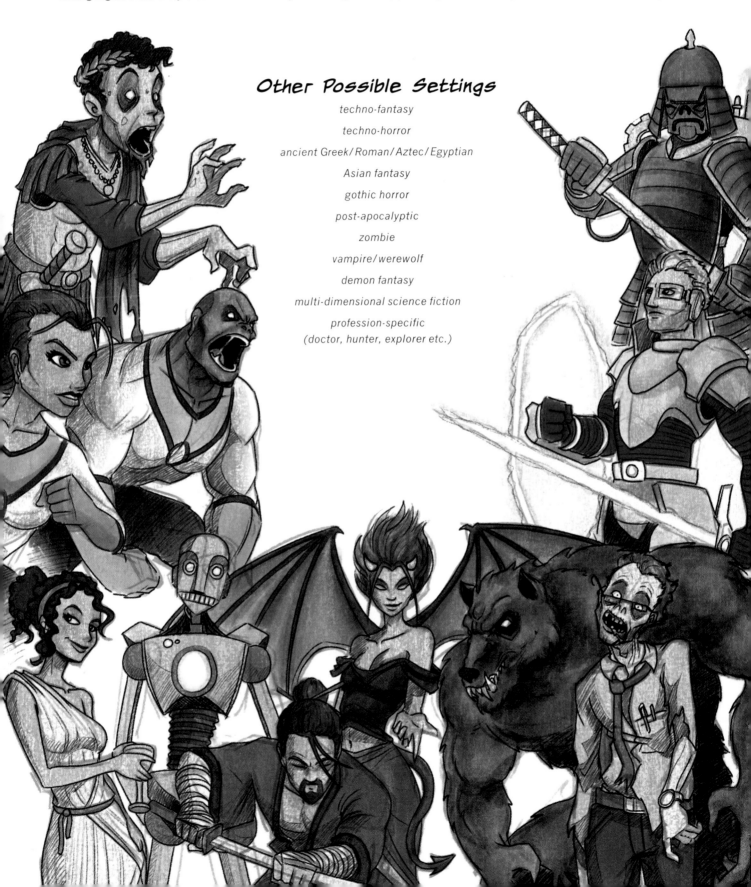

Other Possible Settings

techno-fantasy

techno-horror

ancient Greek / Roman / Aztec / Egyptian

Asian fantasy

gothic horror

post-apocalyptic

zombie

vampire / werewolf

demon fantasy

multi-dimensional science fiction

profession-specific
(doctor, hunter, explorer etc.)

CHARACTER ARCHETYPES

A character archetype is a commonly used, well known or expected character design. Archetypes are a little like templates and are useful in design, mainly due to the fact that artists often have a limited time to present a character, and they want to communicate as much about them and what to expect from them as possible. The better we can do this, the less work the viewer has to do to become fully engaged. In the following pages are some of the most common character archetypes, along with some typical design elements and personality traits.

Using Archetypes

Archetypes are embodiments of a specific type of person or thing, complete with a range of expected motives, attitudes and visual styles. Think of them as starting points for developing particular types of characters, but feel free to break out of the mold.

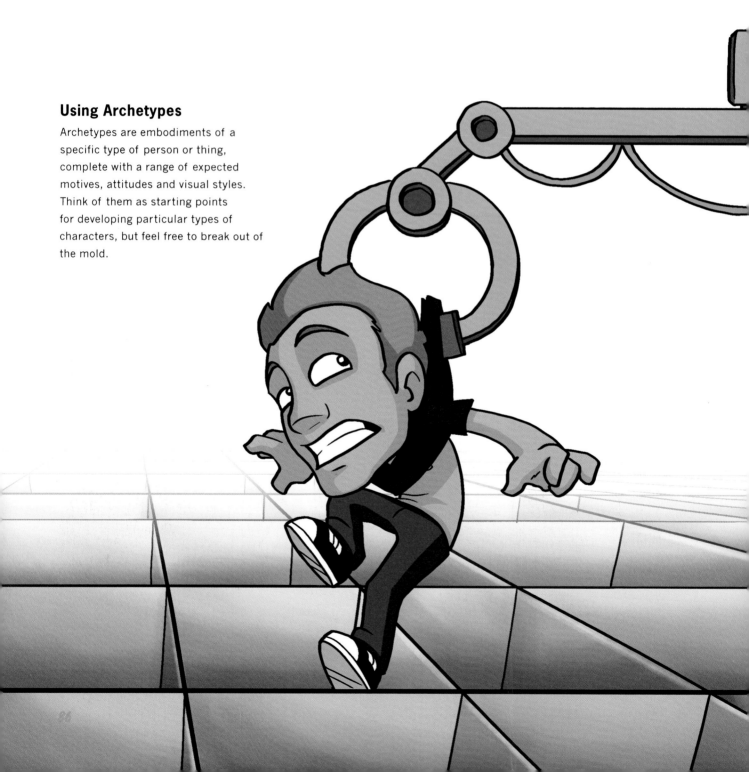

THE HERO AND HEROINE

Also known as the "leading man" or "leading lady," hero and heroine characters don't have to be particularly heroic. They just need to lead. They can also be referred to as protagonists, meaning they lead the story and are major characters. The hero and heroine are often physically well formed, with appealing faces and personalities. Strong posture and design elements in striking colors will help characterize someone as a hero and make the viewer pay more attention to them. Also, hero characters are often neat and well-groomed so they appear reliable, efficient and trustworthy.

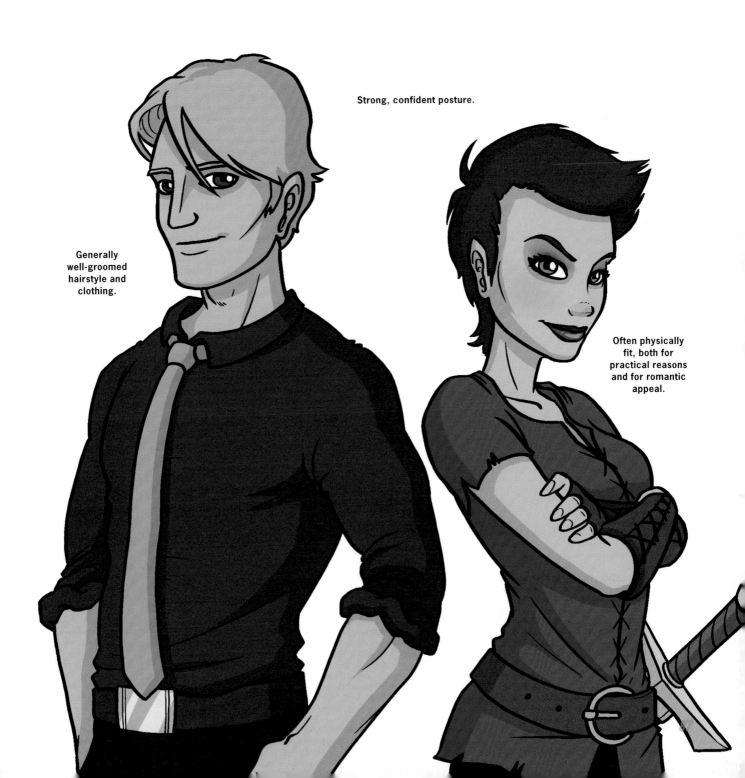

Strong, confident posture.

Generally well-groomed hairstyle and clothing.

Often physically fit, both for practical reasons and for romantic appeal.

THE SIDEKICK

Sidekicks are typically in supporting roles to the main character. These characters can be young and fresh-faced, filled with ambition or an energetic attitude, aspiring to be like the hero. Being naïve means they can make mistakes or be too emotional, but their actions are always well intentioned, if sometimes misinformed. Sidekicks are usually slightly shorter than their hero counterpart, and their poses and postures are often more awkward. For males, it's common to be less muscular than the hero. Female sidekicks are usually less physically attractive (in some aspect) than the heroine. They can have more youthful attire that complements the youthful aspects of their nature. Messy hair or a similar design quirk also complements the sidekick archetype.

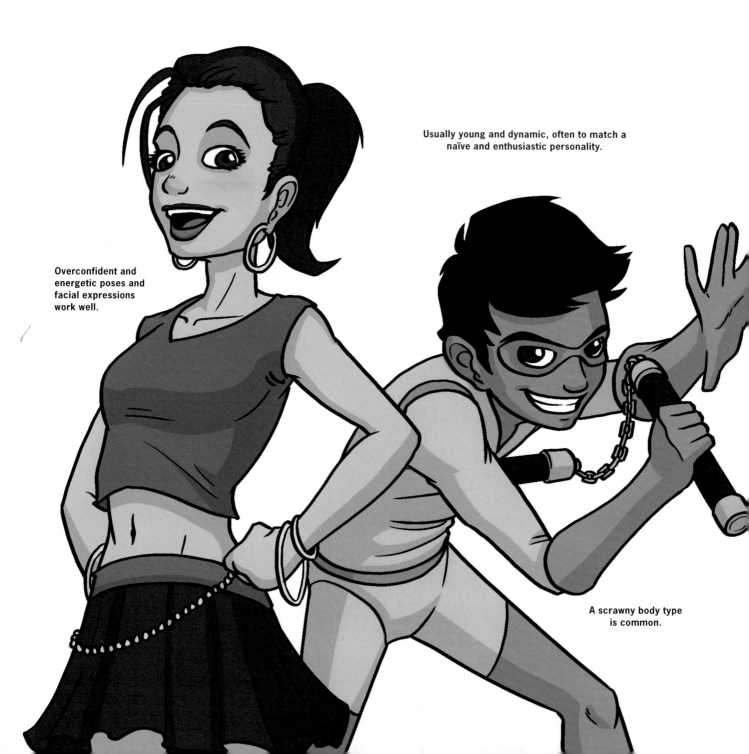

Usually young and dynamic, often to match a naïve and enthusiastic personality.

Overconfident and energetic poses and facial expressions work well.

A scrawny body type is common.

THE MENTOR

In many action and adventure stories, the hero must learn from a mentor before they can become the hero they need to be. Mentors are often older and more experienced. They are usually at least a little bitter (maybe they never lived up to their own potential) and have a goal that they did not achieve or can no longer pursue themselves. They agree to help the hero (who shares the same goal) in order to bring fulfillment to their own desires, too. Mentors are often aged and a little rough around the edges. They typically have graying hair; men may have beards, and women may have glasses or other design elements that accentuate wisdom and experience.

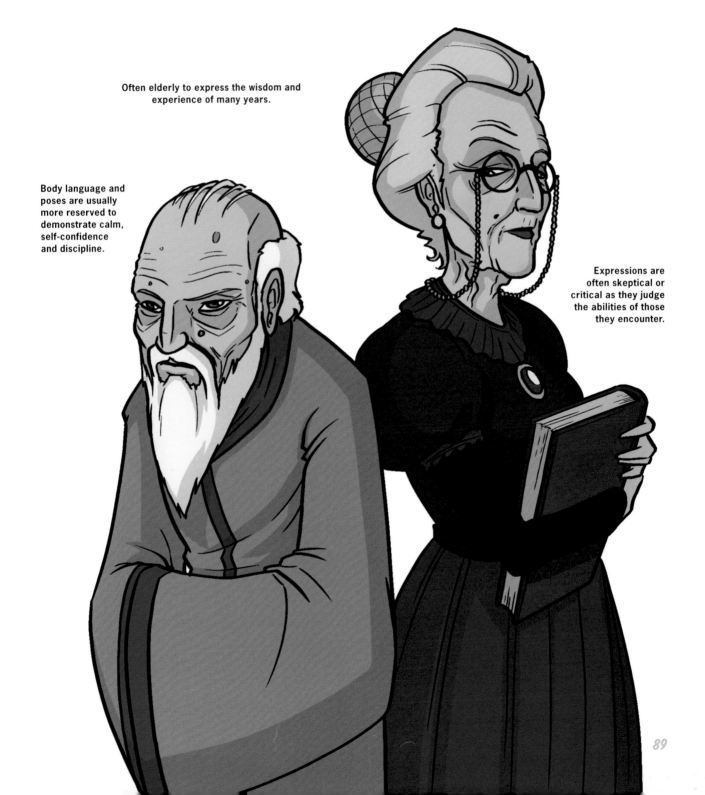

Often elderly to express the wisdom and experience of many years.

Body language and poses are usually more reserved to demonstrate calm, self-confidence and discipline.

Expressions are often skeptical or critical as they judge the abilities of those they encounter.

THE VILLAIN

Villains come in all shapes and sizes, but a cliché villain has sharp features and bold design elements and colors. They must feel powerful and threatening to the viewer, and one of the best ways to aid this is to be clever with their design. The best villains are the ones we love watching, so even though they don't have to be pretty, they must be appealing stylistically or interesting in some way. They are often larger than those around them (in height or width) and show strength in their bearing and posture. Piercing eyes and darker features, such as hair and clothing, are stereotypical when it comes to villains. If they have a handicap (lost hand or anything similar) it has been turned into a weapon. They also need to stand out, so the combination of their hair, outfit and facial/body features is critical.

An arched back and head held high shows an attitude of superiority and power.

Dark colors and hot colors (red/orange) are popular with villains, though not necessary.

Angry eyes with a smiling mouth create a villainous look of cunning and greed.

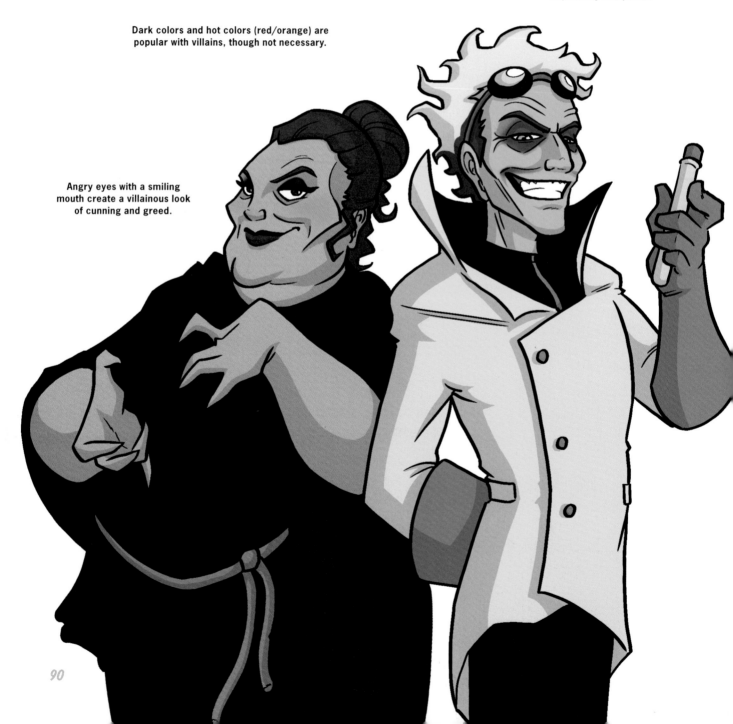

THE HENCHMAN

The henchman (or henchwoman) is the villain's sidekick, who like any other sidekick, is extremely eager to serve and please the person he or she is supporting. Henchmen differ from sidekicks in that they typically have less independence, and they are usually either overemotional or unemotional.

Overemotional henchmen are usually smaller than the hero and villain in height or size to make them more comedic or creepy. Unemotional henchmen/women tend to be large, thick and strong.

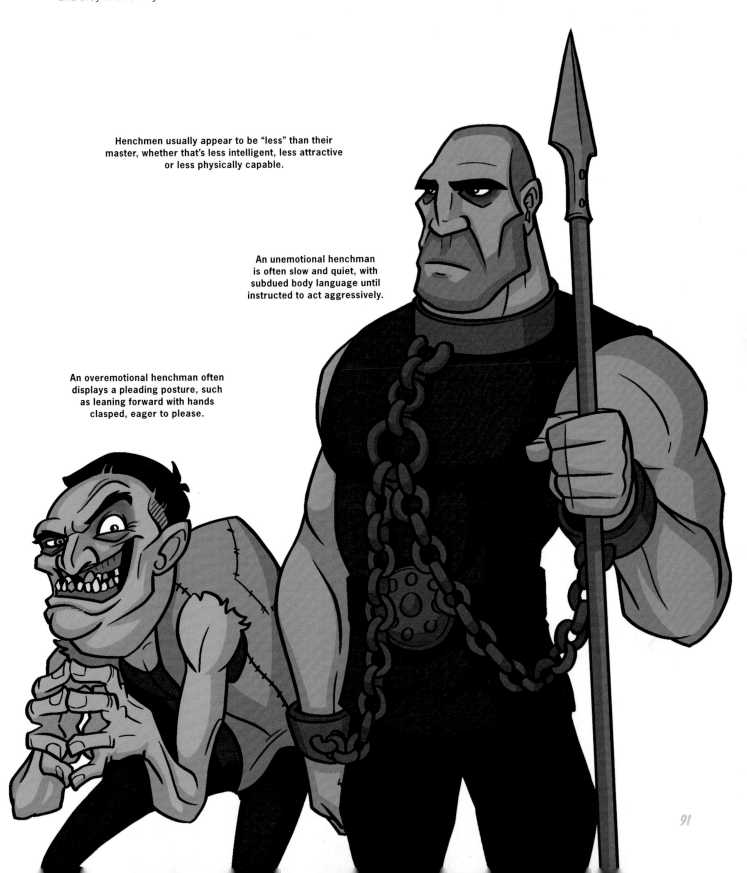

Henchmen usually appear to be "less" than their master, whether that's less intelligent, less attractive or less physically capable.

An unemotional henchman is often slow and quiet, with subdued body language until instructed to act aggressively.

An overemotional henchman often displays a pleading posture, such as leaning forward with hands clasped, eager to please.

THE ANTIHERO

An antihero is a protagonist who lacks typical heroic attributes. Antiheroes aren't gallant; they don't feel any need to be polite or social, and they prefer to work alone, but deep down they want good to prevail even though they're a bit rough around the edges. Visually they often have darker design elements, such as dark eyes, hair or clothing.

Their posture is often insolent, challenging and informal. They are typically unkempt, with torn or ragged clothes, piercings or tattoos—things that visually communicate to the viewer that antihero characters don't care what people think of them.

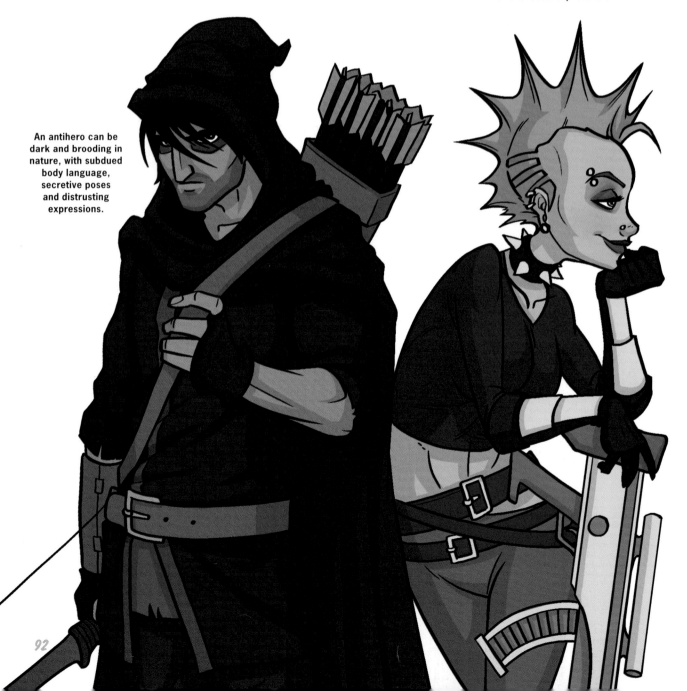

Antiheroes are usually more unkempt than those around them. This can help show visually that they don't care what others think about them.

An antihero can be overconfident and cocky, with ultrarelaxed body language and amused expressions.

An antihero can be dark and brooding in nature, with subdued body language, secretive poses and distrusting expressions.

THE SEX APPEAL

Sexiness is an attribute that can be given to other archetypes (for example, a hero or villain can be sexy), but characters who are specifically designed with sex appeal are often used to move the plot in a certain direction, and it's typically in a bad direction. Sexiness is often used to add appeal while acting as a device to hide untrustworthiness, or is used in the plot to distract other characters from the sexy character's primary objective. Sexy design features include seductive eyes, well-groomed hair, alluring bodies, provocative clothing and bold colors.

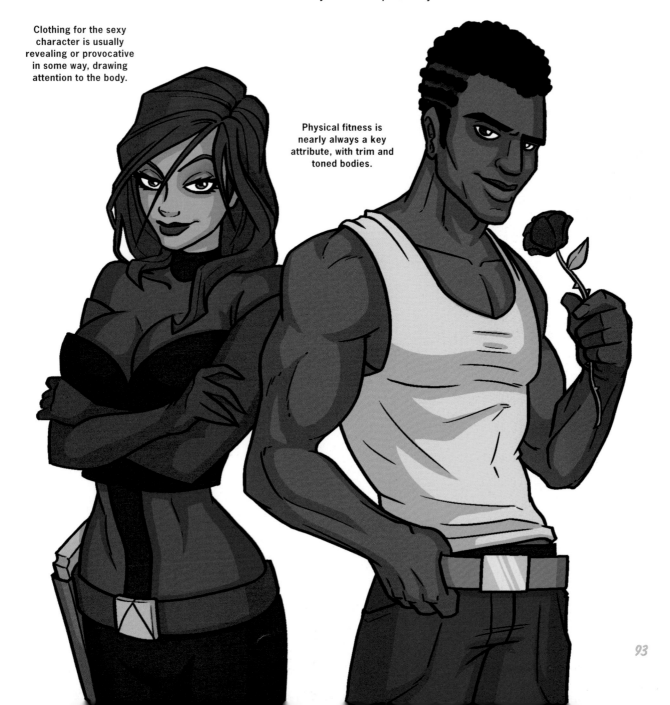

Half-closed eyes with raised or askew eyelids is a common visual cue to convey a seductive personality.

Clothing for the sexy character is usually revealing or provocative in some way, drawing attention to the body.

Physical fitness is nearly always a key attribute, with trim and toned bodies.

THE CARETAKER

The caretaker is sometimes similar to the mentor archetype, visually, but is much softer and less dominant. Caretakers have nurturing personalities and act selflessly, in a parental or protective way. A caretaker will tend to other characters' wounds or emotions and will be an unmovable resource of stability and empathy. These characters are drawn with soft lines, kind eyes and softer color palettes. They are often old, wear simple clothing and live in quaint, unremarkable places.

Usually older, their appeal can be emphasized by showing crow's-feet wrinkles at the sides of their eyes, also called laugh lines.

Caretakers have soft physical features and gentle expressions.

Though not crucial, caretaker characters often wear soft-looking clothing and have a little extra "cushion" on their bodies.

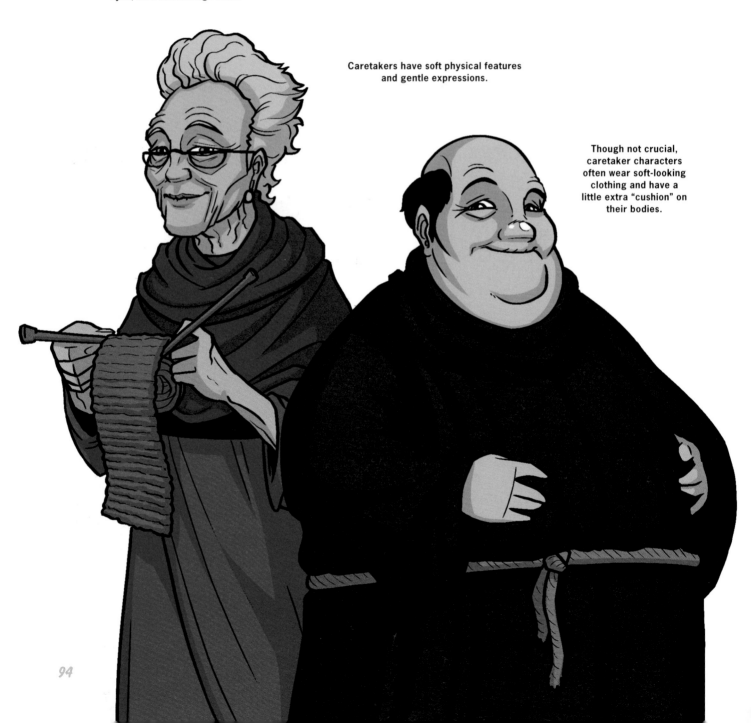

THE ANIMAL COMPANION

Animal companions are the epitome of unwavering loyalty to their master. They are nearly always seen with their master and have specific uses either practically or as a personality to complement or comically contrast with those around them. Visually, they mirror their master. A strong, experienced warrior may have a jaguar, wolf or eagle as an animal companion, for example, and posses sharply designed features and dark, bold colors to complement their counterpart. Meanwhile, a young schoolgirl drawn in a cutesy art style might be accompanied by a squirrel, kitten or puppy. Like any character trait, these common pairings can be played with and turned on their heads for interesting effects.

An animal companion is always loyal to its master and is usually wary of the villain before their master is.

These creatures often have some feature that visually sets them apart from normal animals, like a collar, item of clothing or interesting design element.

Animal companions can be both whimsical and fierce, but they usually lean towards one more than the other.

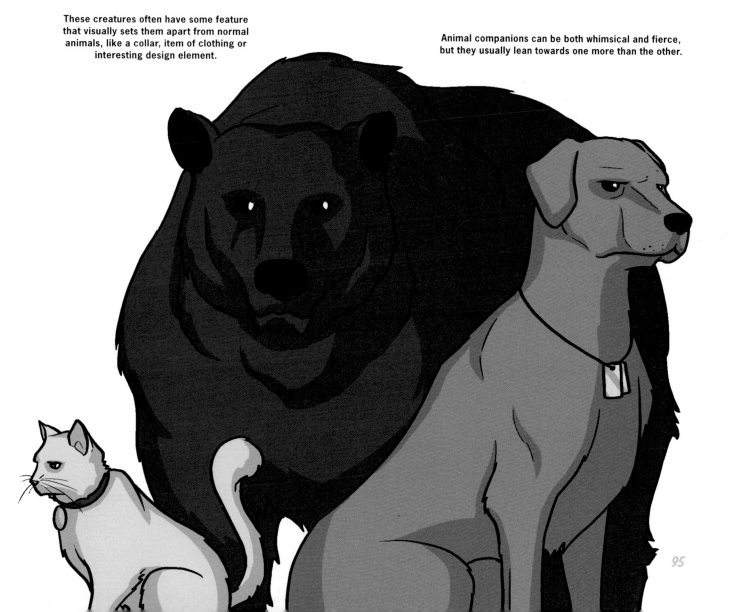

USING STEREOTYPES

Sometimes it's important or desirable for the audience to be able to easily decipher clues about the characters and form immediate impressions or opinions about them. As artists and designers, it's our job to leave these clues with clarity to achieve the desired effect. If the characters are difficult to interpret visually (which could be caused by misleading visual cues or the absence of effective cues), the audience may become confused and make false assumptions, which means the character's design is not adequately communicating the message.

If the character is a mechanic, the audience won't know that until they see items they associate with mechanics, such as lines on oil-stained overalls, gloves and a wrench. That doesn't mean you must constantly apply obvious clichés to your characters, but it does mean that, if you can figure out the most communicative visual cues at your disposal and use a select few in a clever way, you can produce some great results.

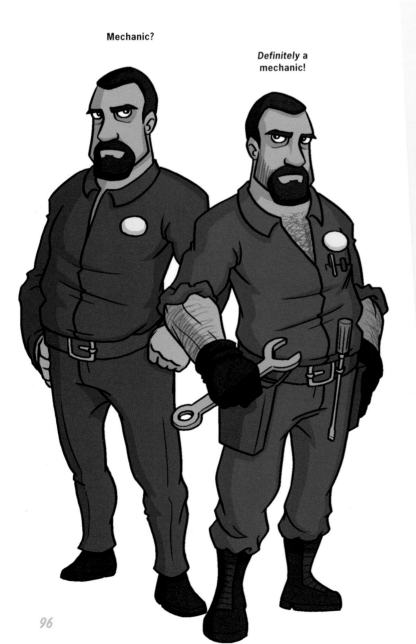

Mechanic?

Definitely a mechanic!

Character Roles with Cliche Visual Cues

- **Lawyer:** *Expensive business suit and tie; briefcase; yellow legal pad; cell phone; clean-shaven look with short, well-groomed hair; and a tall, trim body type*

- **Chef:** *Chef's hat; white chef's clothes; apron; rolled-up sleeves; kitchen tools; hand towel tied to the waist; and a thick waist or big belly*

- **Medieval Knight:** *Sword; armor; beard or facial hair; tabard; shield; horse; cloak; and a tall muscular body*

- **Sci-fi Adventurer:** *Durable, partially worn-out clothing; weapons and adventure equipment; cool tech; communication device; slim or athletic body type; and outlandish hair or clothing*

- **Supermodel:** *Ultrastylish, modern clothing; well-groomed hair and features; small purses; designer jewelry; tall thin bodies; and long legs*

BREAKING EXPECTATIONS

Using character stereotypes can be particularly useful when we want to set up our audience for a surprise. People are hardwired to make assumptions and form opinions based on the visual aspects of our characters, and we can use that to our advantage to hide unexpected intentions, personality aspects and more. This can create interest, humor or depth in the character and the story.

Donnie "the Shank"

Brooding, contemplative and unemotional, Donnie is the on-call hitman for a big-city gang. There are many stories surrounding how Donnie came to be called "the Shank," each of them more unnerving than the last.

The Twist: Donnie is only working for the mafia boss because they are blackmailing him and have been threatening to hurt his ex-wife and child for many years. Donnie is known as "the Shank" because of how aggressively he is working for the gang to gain enough trust, no matter what it takes, to eventually get close enough to the boss to take him out and ensure the safety of his child.

Mary-Sue

In a colorful 1960s-era setting, Mary-Sue is new to town and has caught the eyes of more than one of the boys at high school. Mary-Sue is a sweet-as-pie girl with good marks and a positive attitude.

The Twist: Mary-Sue is one of several artificial intelligence robot prototypes developed by the government to mimic human interaction to an incredibly accurate level. Mary-Sue is the first prototype programmed to manipulate the actions of testosterone-driven males so the government can examine their primitive responses.

Sir Cedric the Brave

Cedric is a knight of the Order of the Golden Arm, dedicated to protecting the weak and upholding justice. He is trusted by the highest of nobility, including the king himself, and is spoken of as one of the most talented combatants in the kingdom. The rumors of his brave feats are spread far and wide.

The Twist: The tales of bravery told of Cedric are the result of bribery and blackmail. While Cedric is certainly not evil, he also isn't as good as he's cracked up to be. He only wants respect from his superiors and to ascend the ranks of nobility. Nobody has ever actually seen him fight or defend the weak, but he speaks of his acts so confidently and gracefully, people think they surely must be true!

1. Discover

2. Design

3. Develop

STAGE 4
DELIVER

This is the final stage of the design process, when the character you have designed is ready to be drawn as the deliverables (polished character art) for your project. The delivery stage can mean different things depending on the medium or context for which your character was designed. For instance, if you designed a cartoon character to be animated, the delivery stage might entail producing a character turnaround and an expression sheet for the animator to use as a reference.

In this chapter we'll go through many of the most common ways to finalize and present your character's design.

4. Deliver

REFINED CONCEPT ART

Concept character art pieces are the most straightforward way to communicate the final design of a character. Producing one entails creating a refined depiction of the character in an easy-to-interpret pose, wearing their most common expression and outfit. There are a few benefits to producing a refined character concept: you as the designer end up with a feeling of closure knowing you've produced, polished and presented a finished character, and you have a clear point of reference moving forward.

Concept pieces aren't required to be digital; you can produce perfectly suitable pieces on paper with pencils, pens and colored markers.

It's also useful to keep in mind that communication is key. Showing your character at a three-quarter angle is important because in a front or side view we're missing out on showing the design's depth and clarity. A finished concept piece of a character should also show the entire character, from head to toe.

Whiplash

Whiplash is a female antihero from a superhero comic book, whose past is shrouded in mystery. Her powers include superhuman accuracy with her whips, superspeed and incredibly fast reflexes. The comics she will appear in use a slightly realistic cartoon style with plenty of solid black shading and detail.

Whiplash's (primarily) black and purple costume has practical and thematic purposes. The dark colors help her hide at night when she fights crime, but they also communicate to the audience that she is mysterious and means serious business.

Goyder

Goyder is a gluttonous crime boss from the planet Xeveddron. He travels with his mafia from planet to planet smuggling contraband and is unstoppable in the intergalactic crime world, but his greatest weakness is food. He will be reproduced in animated format, so his design should be clean and well-shaped, without too much detail.

Goyder is green because it is a common color for aliens in pop culture and will be easy for the audience to digest, and also because it's sometimes viewed as a "sickly" color, which helps emphasize his repulsiveness.

Casey

Casey is a preschool-age genius, already inventing incredible devices. Unfortunately, her parents don't know this and often throw away her creations, thinking she is just playing and connecting bits of rubbish. Casey is extremely optimistic and will always find a new thing to invent. She will appear in a children's storybook, in a colorful and easy-to-look-at style with pencil texture used throughout.

The textured style of Casey's design is intended to make her more appealing to readers, as if she were a hand-drawn creation. This will hopefully help make her more approachable to young readers, as well as visually memorable.

HEAD TURNAROUND

A head turnaround communicates the structure of a character's head at various angles. This is particularly useful where the intended format of the character requires many reproductions and various angles, such as in comic books or animation. It is also recommended to provide (at least) a character's head turnaround when other artists will be producing the content, so there is a clear guideline that demonstrates form and proportion.

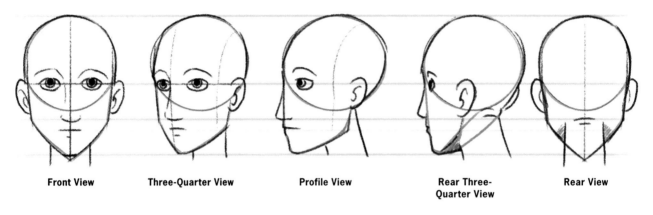

Front View	Three-Quarter View	Profile View	Rear Three-Quarter View	Rear View

Required **Optional**

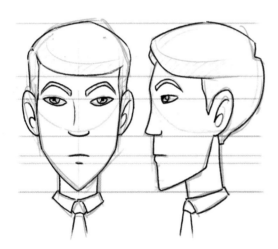

Use Guidelines

The easiest way to produce a head turnaround is to draw one angle of the head (whichever is easiest for you to accurately create), and then draw a few light lines spreading from the most important anatomical landmarks. These can include (but aren't limited to) the top and bottom of the head, the bottom of the nose, the eye line, the opening of the mouth, the hairline at the front of the head, etc.

Use Neutral Expressions

A head turnaround should only hold a neutral expression, never anything extreme. Think of it like an amiable mugshot.

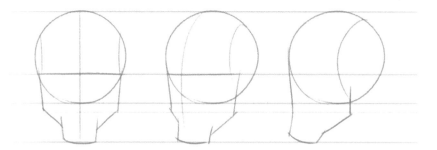

1 SIMPLE CONSTRUCTION AND BLOCKING

Rough out the construction lines of one head angle (I often begin with the front). After sketching the most prominent features on that head angle, draw some lines extending to the side which you can use as a guide in the construction for your other head angles. At this stage, the most important thing is to ensure that the core shapes of the head (cranium and jaw) are properly represented on each angle and that all proportions are accurate.

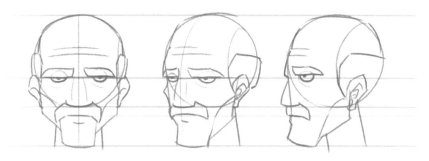

2 SHAPE REFINEMENT AND ADDING DETAILS

Construct the other angles of the head, beginning with the head shape, then go into the details of the head. Be sure to maintain the proportions of these major facial features between each head angle. Check (and double check) as you go! Some of the most important features are the eyes and eyebrows, the nose, the mouth and the jawline. These shapes tend to change the most on each of the angles, and they also impact the character design the most, so be careful to remain consistent.

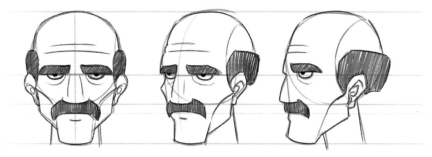

3 FINAL PRESENTATION

Once you're 100 percent happy with your character's facial construction, create the refined lines on top using your favorite medium. As with proportions and expressions, make sure the line weights and details are represented clearly and similarly across all angles depicted.

FULL-BODY TURNAROUND

The purpose of the full-body turnaround is the same as the head turnaround, with the obvious difference of drawing the entire character rather than just the head. A full-body turnaround is more appropriate than just a head turnaround if the character depicted has an outfit they wear most of the time, and if the character is expected to be shown in a variety of angles and poses.

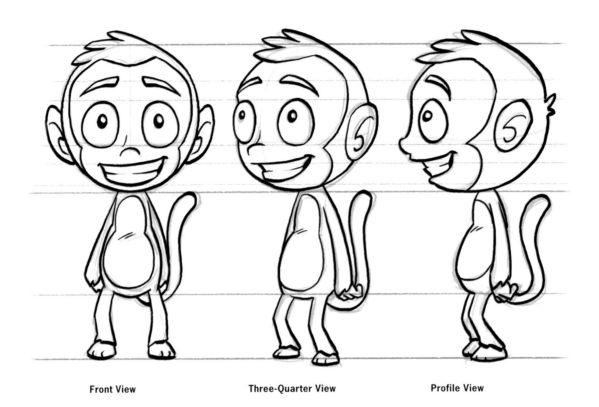

Front View Three-Quarter View Profile View

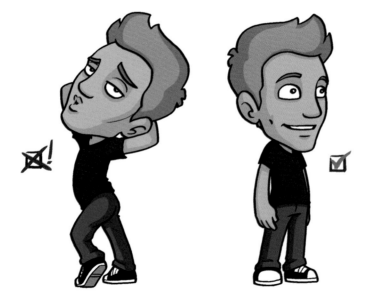

Keep It Neutral

The body must hold a "neutral expression" in the same way a face must be neutral in a head turnaround. This means no raised limbs or strong poses. A character's personality may be expressed through their stance, but this should be limited so that the focus is on the design and proportions. For example, a superhero might stand in a strong, upright pose with the chest out confidently, or a loner might be shown with a slight slouch, but these characters should still be standing upright and not differ too much from an emotionless neutral character pose.

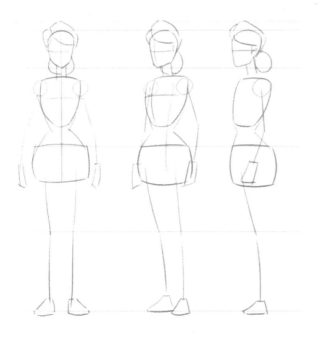

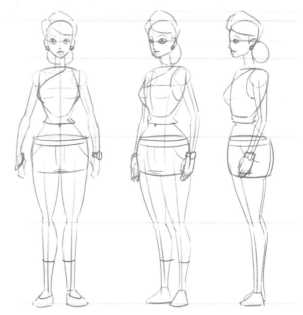

1 SIMPLE CONSTRUCTION AND BLOCKING

Begin with the construction lines of a single body angle and pose, being careful to represent the final design proportions as you go. When you're happy with this, draw lines out from the main limbs and body parts (such as limb joint heights, midriff, shoulders, etc.) as guides for constructing the other angles.

2 SHAPE REFINEMENT AND ADDING DETAILS

Create the construction lines for the other angles. Make sure the pose and proportions are as accurate between these angles as possible. From here you can begin to sketch in some of the smaller features, as appropriate, such as texture or details on clothing, props, etc.

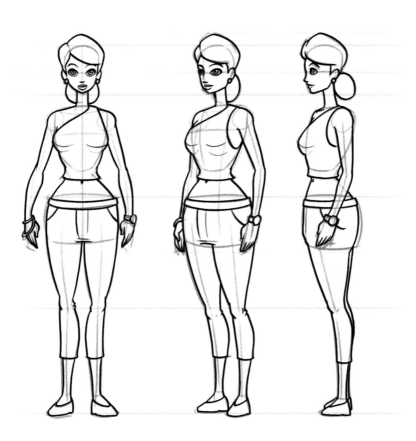

3 FINAL PRESENTATION

Once you're satisfied with the body representations on all of your angles, create the refined imagery (be it line work, painting, vector shapes, etc.).

EXPRESSION SHEET

Any character you create is a performer, and a character's expression sheet is your chance to show the emotional diversity they are capable of expressing. Expression sheets can also be helpful by demonstrating how your character's face distorts, since no two characters should be angry or happy in exactly the same way.

An expression sheet often accompanies a refined concept piece or a turnaround of some kind. This is because the expression sheet doesn't provide a clear demonstration of proportions on its own.

It's also important to show a range of extremity suited to the character's personality. For example, a quiet character who is often dark and moody will have an array of negative expressions, such as angry, suspicious or conniving, with very few jovial expressions. The expression sheet is an opportunity to communicate the visuals of a character's design while also demonstrating personality and disposition.

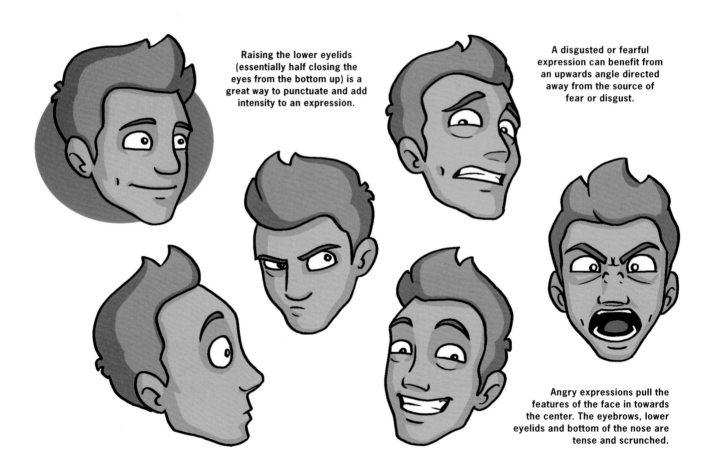

Raising the lower eyelids (essentially half closing the eyes from the bottom up) is a great way to punctuate and add intensity to an expression.

A disgusted or fearful expression can benefit from an upwards angle directed away from the source of fear or disgust.

Angry expressions pull the features of the face in towards the center. The eyebrows, lower eyelids and bottom of the nose are tense and scrunched.

Try Different Angles

Drawing each head on a slightly different angle will reinforce the 3-D solidity of the character and show how the face distorts in various angles.

Neutral Is Necessary

Always include a neutral expression, so the extremes of emotion shown in the other examples have a base or context for comparison.

Design Brief: Victoria

Victoria is the protagonist in a modern romantic graphic novel. She is shy and kind. The visual style of the graphic novel series is semi-realistic and highly detailed. She is shown with natural expressions as much as possible (not too over-the-top).

A neutral expression is provided to demonstrate the emotional baseline of the character and to clearly show the proportions of her facial features.

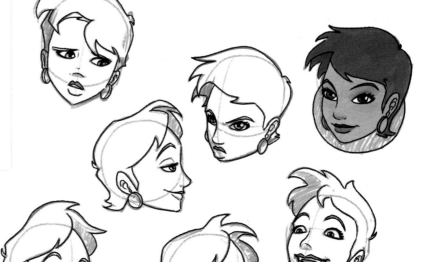

As a comic-style character, Victoria is drawn with boundaries as to the extremity of her expressions—with expression, but not so much exaggeration that the readers won't relate to her or take her seriously.

It Can Be Rough

An expression sheet doesn't require every drawing to be 100 percent refined and colored. It is enough to just show the neutral expression as a refined image, while the rest can simply show construction lines and line work, if desired. It may even be helpful to show this rough art, as it demonstrates how the angles and expressions were formed.

These various expressions will demonstrate, to whoever ends up drawing her in the final comic, how her hair moves with the position of her head and changes shape according to her motion.

As a much more cartoony character, Grup's proportions and facial features can be pushed to more extremes than in our previous example.

Grup's large, round eyes can be really squashed and stretched to push his expressions to their limits.

Design Brief: Grup

Grup is a Neanderthal with a cartoony and appealing face, and he is very expressive. His image is used in all kinds of scenarios that depict Grup performing manly caveman activities.

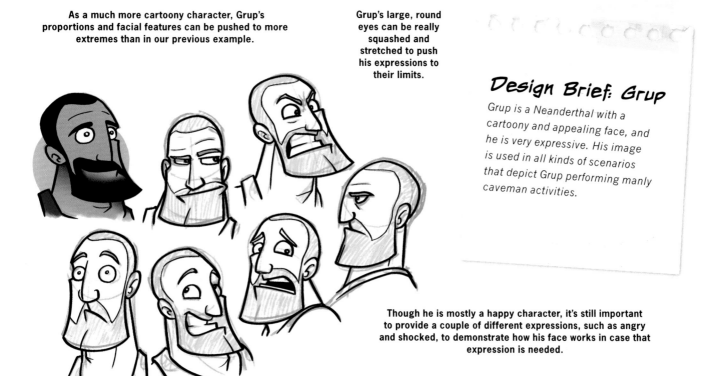

Though he is mostly a happy character, it's still important to provide a couple of different expressions, such as angry and shocked, to demonstrate how his face works in case that expression is needed.

POSE SHEET

Much like the expression sheet, the purpose of a pose sheet is to demonstrate diversity and flexibility, and what is appropriate in terms of a character's personality. I recommend including a refined depiction of a neutral pose. Be sure the varying character poses are suited to the character's range of movement. Active characters should have varied and dynamic poses, but fairly passive characters will have less dramatic pose sheets.

Make It Natural

The poses should look natural and suited to the character, not just be extreme for the sake of extremity.

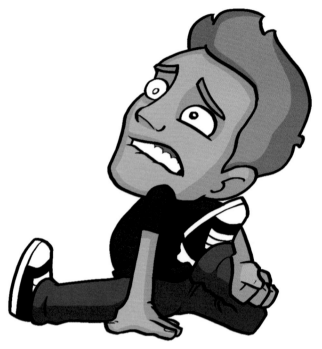

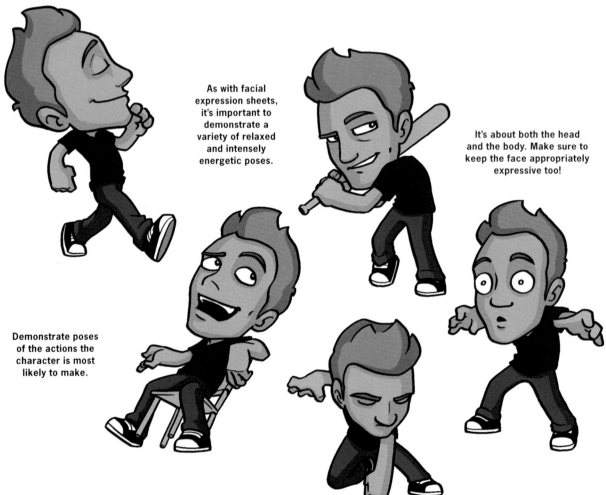

As with facial expression sheets, it's important to demonstrate a variety of relaxed and intensely energetic poses.

It's about both the head and the body. Make sure to keep the face appropriately expressive too!

Demonstrate poses of the actions the character is most likely to make.

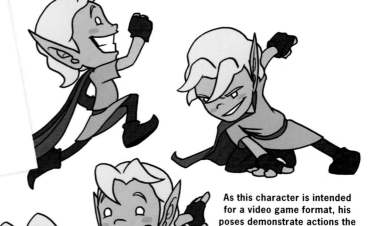

Design Brief: Dayle

Dayle is a half-elf adventurer for a children's video game. His character will be exploring fantasy worlds and taming beasts of all kinds on his journey to rescue his sister. He will be required to move dramatically and be very expressive with his body, in a cute, cartoony way.}

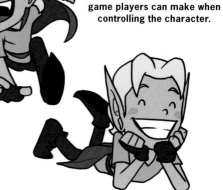

As this character is intended for a video game format, his poses demonstrate actions the game players can make when controlling the character.

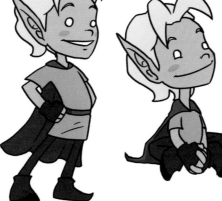

The animators of the final in-game version of this character will need to see just how extreme his poses can get so they have a frame of reference.

Design Brief: Tabatha

Tabatha is a cat created for a cute series of internet videos. Her poses and movement won't be extreme, but she will be animated doing various things. A pose sheet is required to show how she looks in the most common actions.

Although Tabatha is a simple character, her body can still change shape drastically.

VARIANTS

In some cases, a character will only ever have one look, such as in comic strips or TV cartoons. On the other hand, sometimes a character will have several visual looks or styles they alternate between. For these situations, it can be beneficial to provide (whether for yourself or for a client) a sheet of visual variants. This can either be used to show several core outfits the character will be wearing, or even to show a character's different forms, such as a superhero who transforms completely into another type of being.

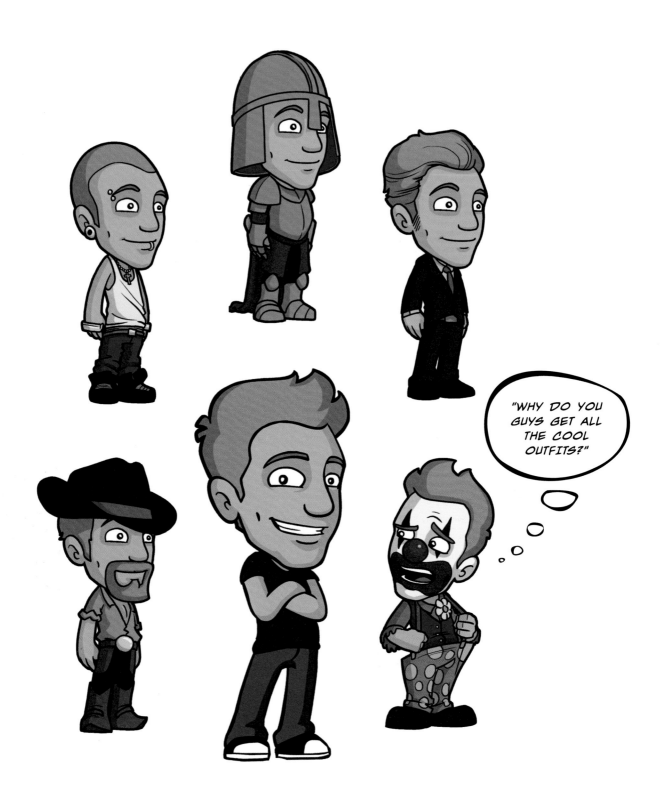

"WHY DO YOU GUYS GET ALL THE COOL OUTFITS?"

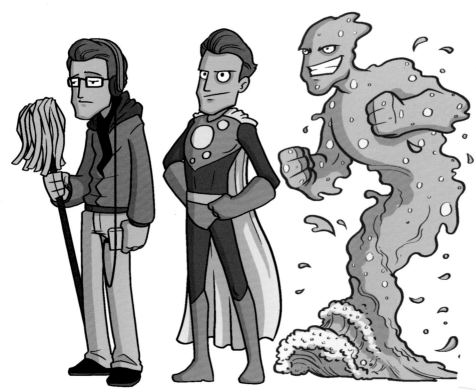

Form 1—Mild-mannered Janitor: Slumped posture, lazy expression and dull colors make him appear to be a dull person.

Form 2—"The Cleaner" Super Suit: Bright colors in a base of blue (for water) make the character stand out; his posture is suddenly confident.

Form 3—Water Form: Though in a completely different physical form, the character's face is still present and must be the same as the other versions of the character to maintain consistency.

Design Brief: Michael

By day, Michael Mathers is a mild-mannered janitor in Brooklyn trying to make ends meet. By night, he's The Cleaner, a superhero with the ability to turn himself into a torrent of hot, soapy water!

Design Brief: Mishka

Mishka is a fashion designer trying to make a mark on the world with her edgy designs. Her designs have been stolen by a famous exclusive designer, so she's taking the law into her own hands by infiltrating their headquarters—with style!

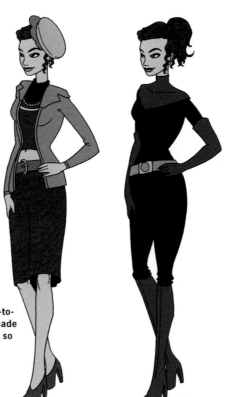

Form 2—Crime Fighter: In both forms Mishka wears only the finest clothing, so to clearly differentiate her forms when fighting crime, she wears mostly leather and metal (to make her look edgier) with darker colors.

Form 1—Fashionista: In her day-to-day form, Mishka's clothes are made up of soft linens in pastel colors so as to appear unassuming.

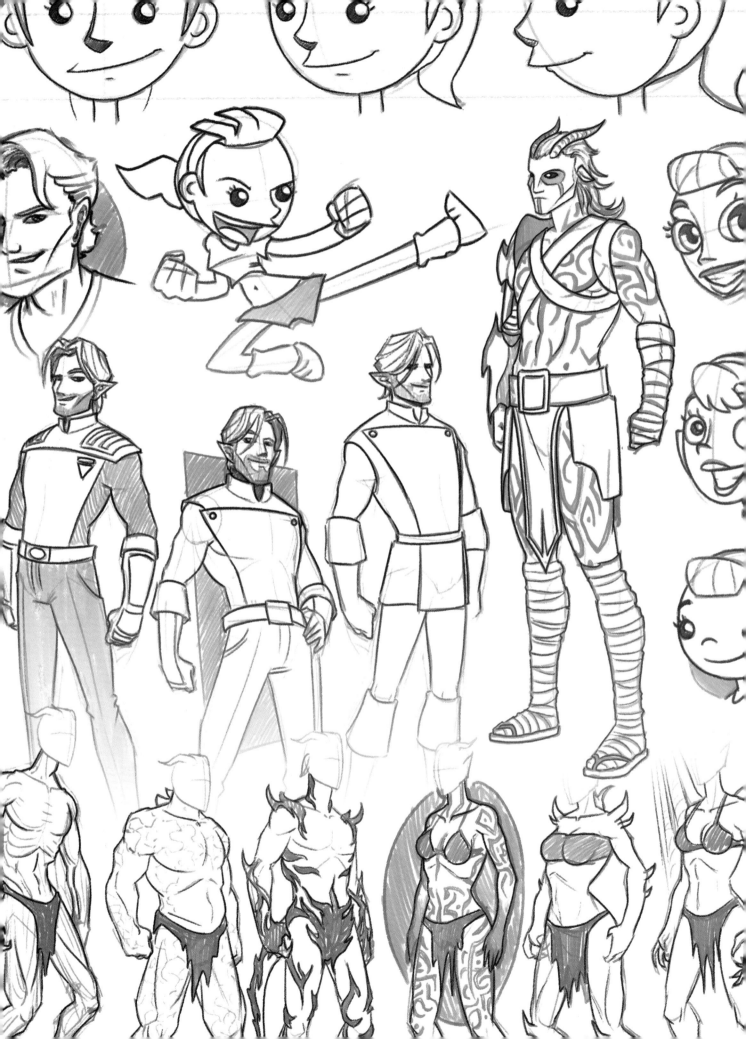

STAGE 5
PULLING IT ALL TOGETHER

When you go through the design process from start to finish, you should feel confident in your finished design and satisfied with its execution. If something isn't right, then go back a step or two. If it's still not working, go back to the discovery stage and take a careful look at the initial planning questions. Compare the answers to the questions with your final result and try to pin down where you missed the mark.

Up to this point we've gone through the design process stages in detail. In the following pages, I demonstrate the creation of four unique characters, each with a different style and intended application. With each character, the design process will be shown chronologically, including notes on why certain decisions were made. The end result (delivery) for each character will be slightly different, since each character is created for a different context.

Design Process Review

To recap, these are the stages of the design process that will be demonstrated, and in this order:

Stage 1: Discover

The character concept is developed and refined, including some research on the intended medium and marketplace.

Stage 2: Design

The character's design is developed by using relaxed and exploratory brainstorm sketches. The most effective traits and design features are highlighted for further development.

Stage 3: Develop

The most effective and appealing designs are further refined and experimented with by mixing and matching or tweaking aspects of the design.

Stage 4: Deliver

The final design is produced for its final application or delivered to its next recipient.

QUAID THE SPACE CAPTAIN

Quaid is a half-human, half-alien space captain in a utopian science fiction world set in the year 3537. Quaid is twice as lazy as he is wealthy, and he is *very* wealthy. He considers himself a ladies' man, is incredibly vain and has never had to deal with the consequences of his reckless and selfish actions. Quaid is being developed for a graphic novel aimed at young adults and adults.

DISCOVER

MARKETPLACE RESEARCH

There aren't many characters with similar personalities and dispositions in graphic novel form, or depicted with the extremity that Quaid will be. However there were a few cartoon characters from television that bear similar traits, so Quaid should be careful to avoid similar design features, and his personality concept should be refined to be more original.

DESIGN RESEARCH

Big boots or gloves work well to emphasize an overbearing personality. Tight clothes could potentially accentuate Quaid's vanity. Sunglasses might work well to make him look guarded emotionally and even hungover from being a late-night partier.

CONCEPT REFINEMENT

Quaid could benefit from some depth to his character that can be explored later in the story arc, such as the loss of a sibling or a huge mistake he made as a captain years ago that got many of his former crew killed or captured.

DESIGN

I did several character sketches for Quaid, and afterward I highlighted my favorites and added notes about what I liked about each.

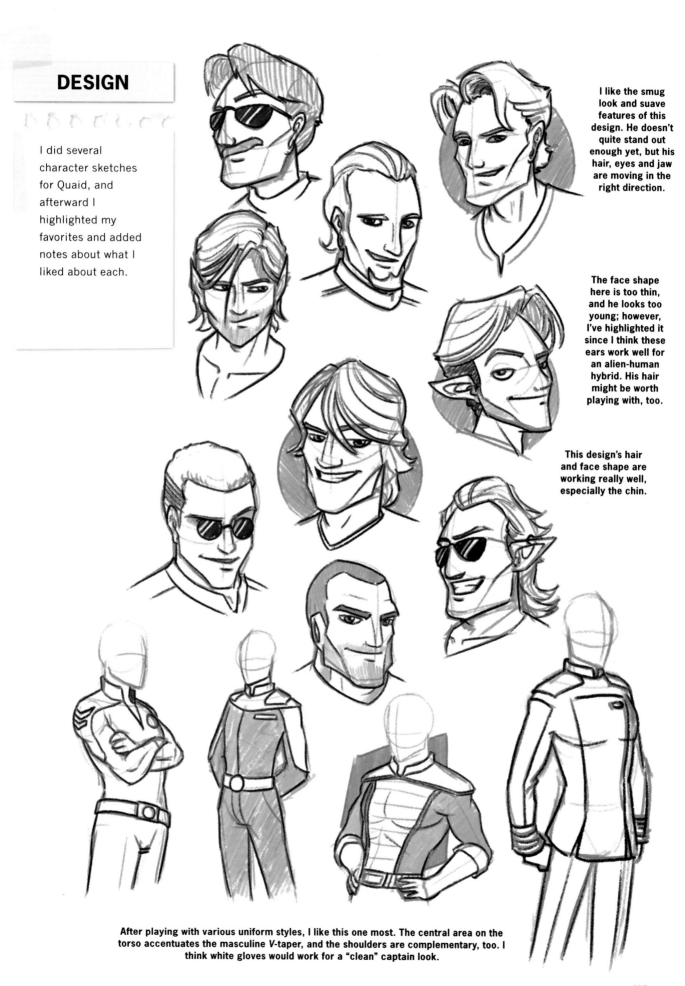

I like the smug look and suave features of this design. He doesn't quite stand out enough yet, but his hair, eyes and jaw are moving in the right direction.

The face shape here is too thin, and he looks too young; however, I've highlighted it since I think these ears work well for an alien-human hybrid. His hair might be worth playing with, too.

This design's hair and face shape are working really well, especially the chin.

After playing with various uniform styles, I like this one most. The central area on the torso accentuates the masculine V-taper, and the shoulders are complementary, too. I think white gloves would work for a "clean" captain look.

DEVELOP

With my favorites narrowed down to two or three each for the head and body, I put together my favorite elements from each to refine my design.

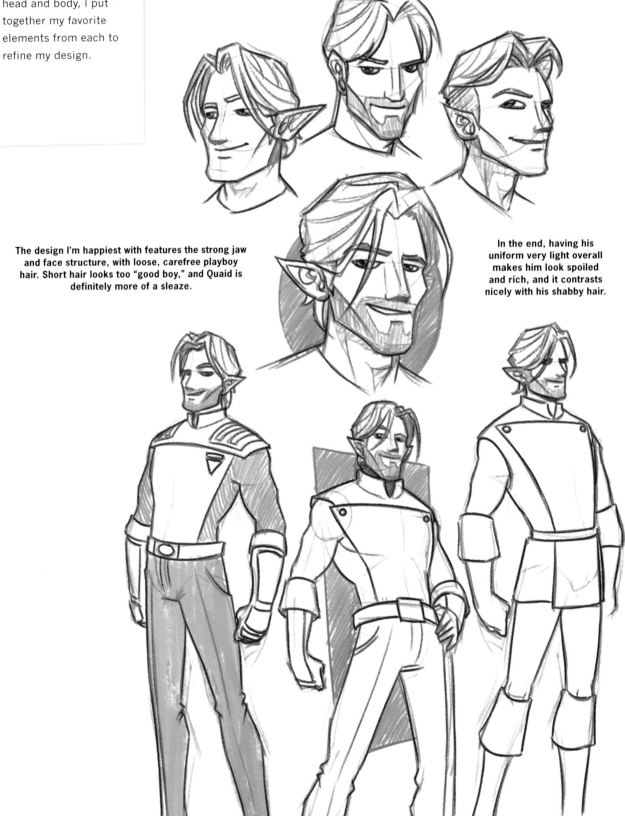

The design I'm happiest with features the strong jaw and face structure, with loose, carefree playboy hair. Short hair looks too "good boy," and Quaid is definitely more of a sleaze.

In the end, having his uniform very light overall makes him look spoiled and rich, and it contrasts nicely with his shabby hair.

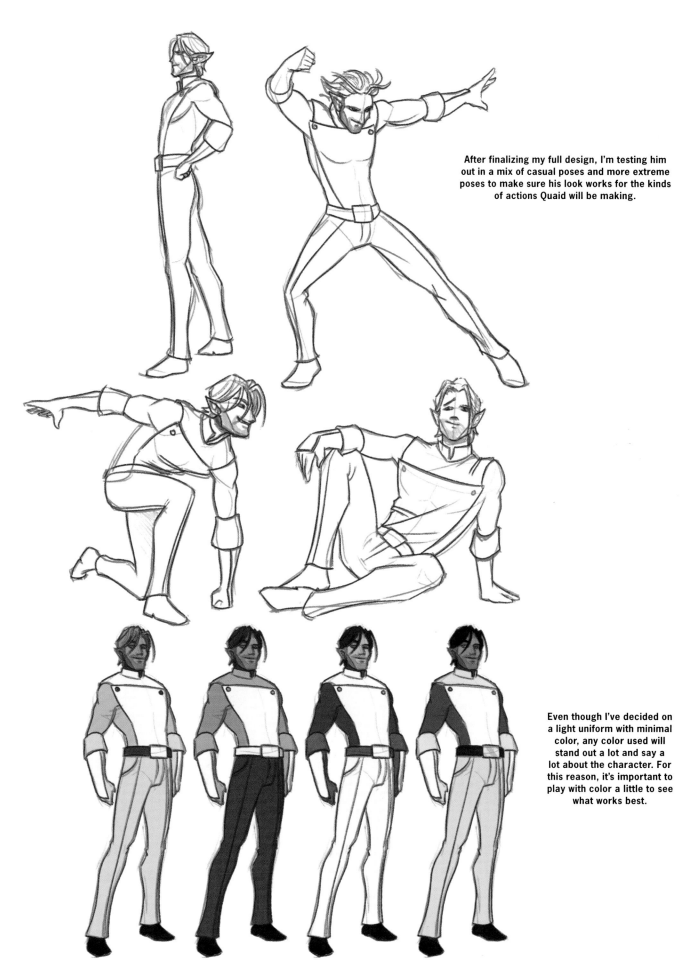

After finalizing my full design, I'm testing him out in a mix of casual poses and more extreme poses to make sure his look works for the kinds of actions Quaid will be making.

Even though I've decided on a light uniform with minimal color, any color used will stand out a lot and say a lot about the character. For this reason, it's important to play with color a little to see what works best.

DELIVER

For deliverables, I created a refined character concept, a full-body turnaround and an expression sheet.

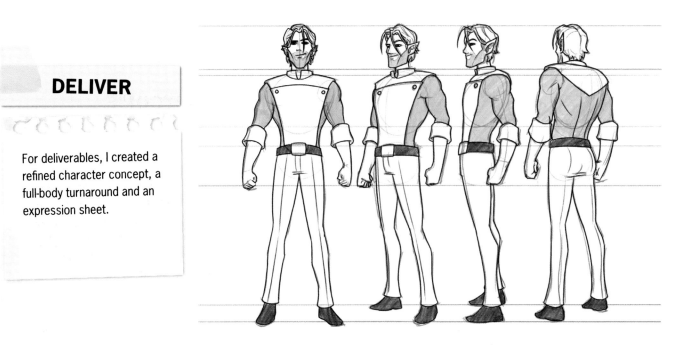

Character Turnaround for Base Reference

Quaid's character turnaround provides a reference for his base stance and expression, as well as a clear guide to drawing his proportions and clothing.

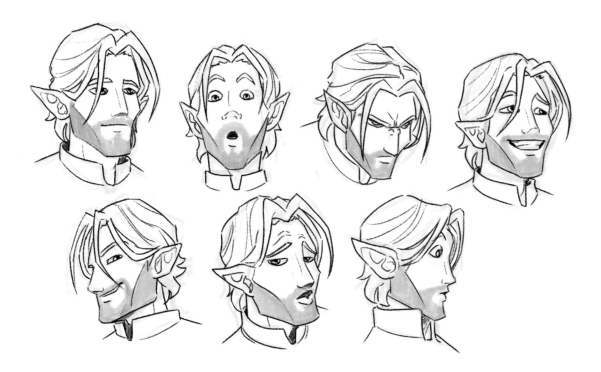

Demonstrating Dynamism with Expressions

Quaid's expression sheet demonstrates the relaxed nature of his neutral pose and the dynamism of his various expressions. He is intended to be an extremely expressive character, provoking his audience to react to his antics by overacting and causing mischief. His character sheet should demonstrate this while also hinting at some character depth with a few serious expressions.

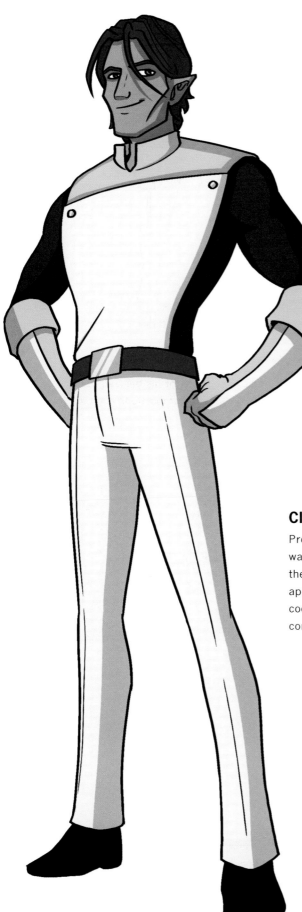

Here is Captain Quaid in his final form, with features chosen that will emphasize his selfishness and hyper-masculinity. A turnaround was chosen as part of the deliverables since, for a graphic novel, it's important that he be consistently drawn from all angles. An expression sheet was produced because it's important for his attitude to be conveyed clearly and for his character to be humorous to the audience rather than repulsive. Finally, a refined concept piece is always nice to have to show off the final design.

Closure with the Refined Concept

Producing a single refined character concept piece is a great way of bringing closure to the design process by demonstrating the final depiction of the character in a natural, visually appealing way. Quaid's final concept piece conveys his generally cocky nature and clearly shows the crisp, clean uniform in contrast with his disheveled hair and relaxed expression.

CINDY THE FITNESS LOVER

Cindy is a twelve-year-old fitness-loving girl. She's always going on adventures and overcoming obstacles with her friends. She wears her favorite sporty outfit on her adventures, as if it were a superhero costume. She tries to show her friends that they can be super strong, super fast and super fit, too. Cindy's adventures will take place through time and space, as in each episode of her animated TV show, she and her friends constantly find themselves pulled into strange dimensions (black holes, time machines, etc.) during recess at school. In reality, it's all a game of their imagination, but this is never explained to viewers. Instead, they go with Cindy through her adventures.

DISCOVER

MARKETPLACE RESEARCH

Very little was found in the way of fitness-oriented female leads for children's television. This means there may be a gap in the market and Cindy could make her mark. However, there is one children's television show (not animated) that could cross over in terms of theme and target audience. Therefore, points of difference are important and the design must reflect this. The main point of difference is the time travel and space/time fiction elements of Cindy's adventure. Cindy should be entertaining through her adventures and personality, so kids can enjoy playing similar games with their friends at school while developing an appreciation for good health and exercise.

DESIGN RESEARCH

Easily adapted female cartoon characters already present in television have a sleek style with solid, clean lines and colors. It would be beneficial to find inspiration and ideas from popular TV characters from the last five years, while making sure to create an entirely original character design for Cindy.

CONCEPT REFINEMENT

While Cindy's outfit and personality shouldn't change, her style should be mixed in an adventure of some kind, with visual aid from creatures, props and locations that vary each time.

DESIGN

I did several character sketches for Cindy, and afterward, I highlighted my favorites and made notes about what I liked for each.

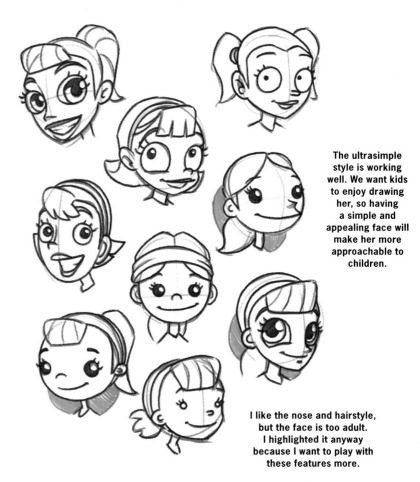

The ultrasimple style is working well. We want kids to enjoy drawing her, so having a simple and appealing face will make her more approachable to children.

The fringe in her hair adds interest and seems preferable to simple, pulled-back hair, but I want to play with it more to decide for sure.

I like the nose and hairstyle, but the face is too adult. I highlighted it anyway because I want to play with these features more.

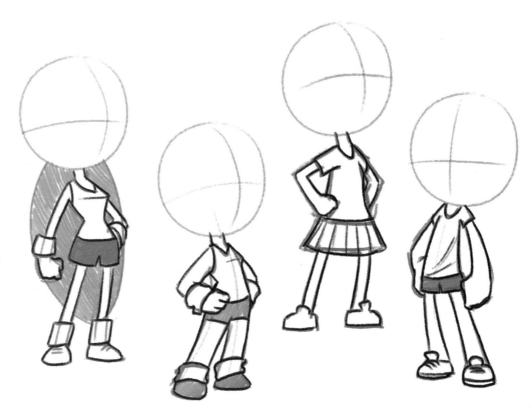

The skirt looks too much like a tennis uniform, whereas the shorts are more flexible in terms of how the character can be used later. I also like the sweatbands, though I'm not yet sure in what combination.

DEVELOP

With my favorites narrowed down to two or three each for the head and body, I put together my favorite elements from each to refine my design.

The features that combined the best but kept the design simple were the fringe, simple black bubble eyes, ponytail and headband. She also works best with a cute, pointy nose and mouth, which can also lend her some attitude so she's not too soft.

Experimentation showed that having both wristbands and legwarmers was too much, so I kept the legwarmers on and left her hands free. I kept her clothes simple with just shorts and a T-shirt. Her shirt shows a little midriff, which makes her look sportier and a little older, too.

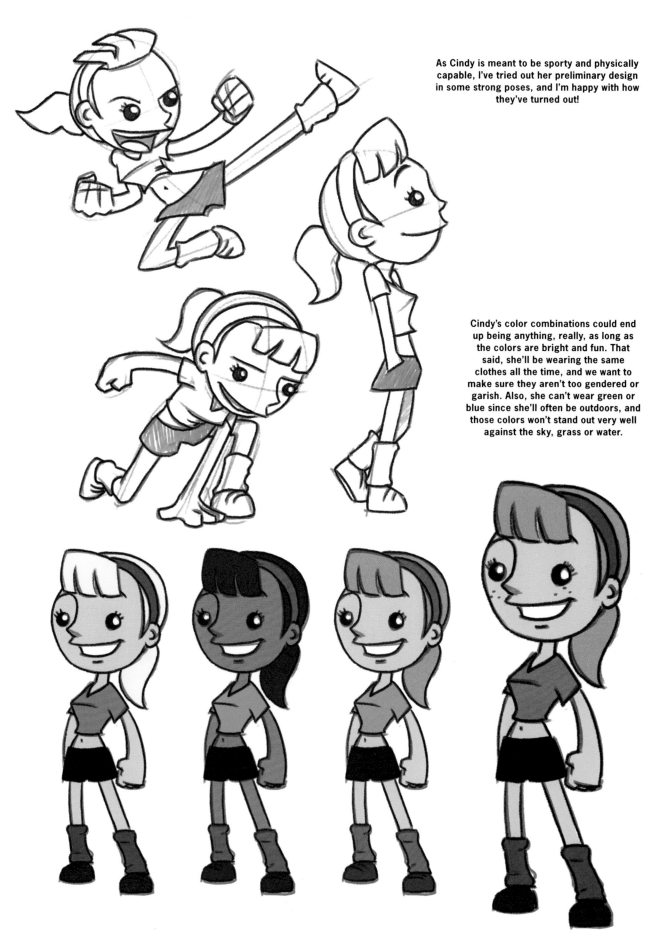

As Cindy is meant to be sporty and physically capable, I've tried out her preliminary design in some strong poses, and I'm happy with how they've turned out!

Cindy's color combinations could end up being anything, really, as long as the colors are bright and fun. That said, she'll be wearing the same clothes all the time, and we want to make sure they aren't too gendered or garish. Also, she can't wear green or blue since she'll often be outdoors, and those colors won't stand out very well against the sky, grass or water.

DELIVER

For deliverables, I created a refined character concept, a head turnaround and a pose sheet.

A cheerful neutral expression in a head turnaround demonstrates the face's shape and proportions.

Front View **Three-Quarter View** **Profile View**

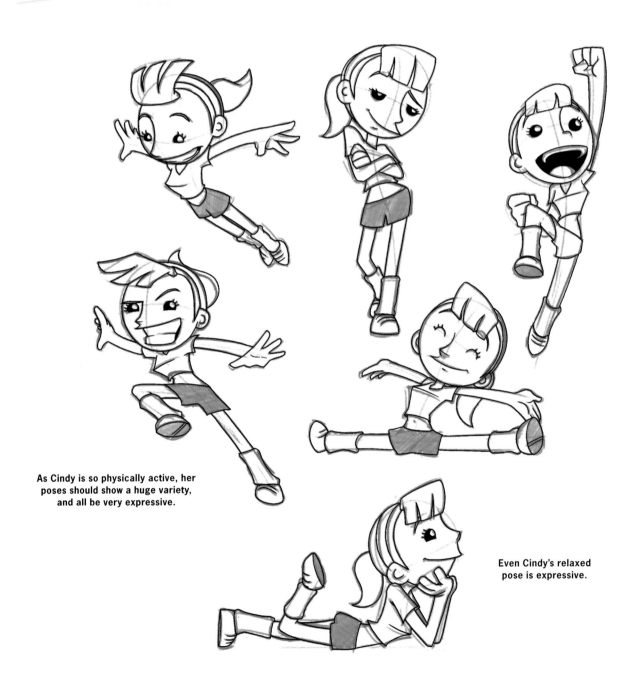

As Cindy is so physically active, her poses should show a huge variety, and all be very expressive.

Even Cindy's relaxed pose is expressive.

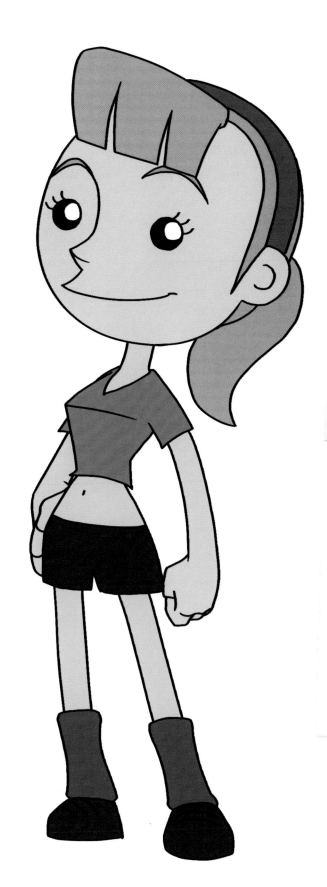

OUTCOME

For Cindy's deliverables, the head turnaround was chosen since a rigid body turnaround wouldn't be as useful as the pose sheet that has also been created. The pose sheet demonstrated her flexibility as a person and her malleability as a character design. Finally, a simple but refined character concept piece was also created, which demonstrates the basic proportions of the character when completely neutral, as well as her intended final style, or look.

THE GRAZGHAR (A RACE OF BEINGS)

A video game company is creating a fantasy world and, though inspired by other games and established fantasy settings, they want their game to bring something new to the table. They want to develop a fantasy race of beings from the ground up.

This particular race is called the Grazghar, and they originate from demonic realms. Much like there are fallen angels in fantasy lore, the Grazghar are a race of ascended demons who have proven that their hearts are not evil and who have been allowed to dwell in human realms. They are visually coarse and often scary or brutish looking, and even though they are good-natured, they're stigmatized or feared by most of the common populace, so they usually keep to themselves. The video game company requires a foundation design concept for two characters, one male and one female Grazghar.

This race is being developed for an open-world massively multiplayer online role-playing game (MMORPG).

DISCOVER

MARKETPLACE RESEARCH

There aren't many playable demonic races in the video game MMORPG market, but there are some extremely well-known and established nonhuman races that should be carefully researched so the Grazghar don't look too similar.

DESIGN RESEARCH

It would be worth experimenting with design features such as stone-skin and molten cracks in the skin, horns, claws, metal clothing and coarse armor, animal "hind-leg" style legs, etc.

CONCEPT REFINEMENT

Although the race is demonic, the final design shouldn't look too menacing and should feel more exotic than threatening while still alluding to its demonic origin.

DESIGN

I did several sketches of possible looks for the Grazghar, and afterward, I highlighted my favorites and made notes about my preferences.

There are many directions in which the demonic look could go, but I felt the thicker faces and horns looked too menacing and decided to go with a slenderer look.

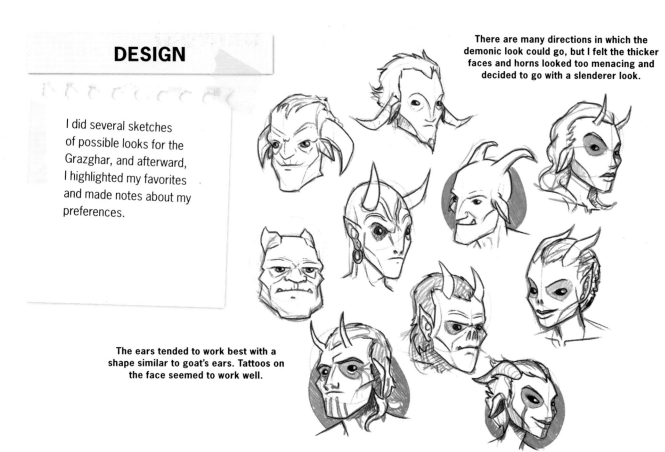

The ears tended to work best with a shape similar to goat's ears. Tattoos on the face seemed to work well.

The tattoos seem to be a nice theme to carry over into the body, using them as a good way to show a demonic origin without adding too many sharp spikes or design aspects that look inherently threatening.

Without being given a specific skin texture or style that the developers wanted, I thought I'd try a wide variety for both genders and see what stood out.

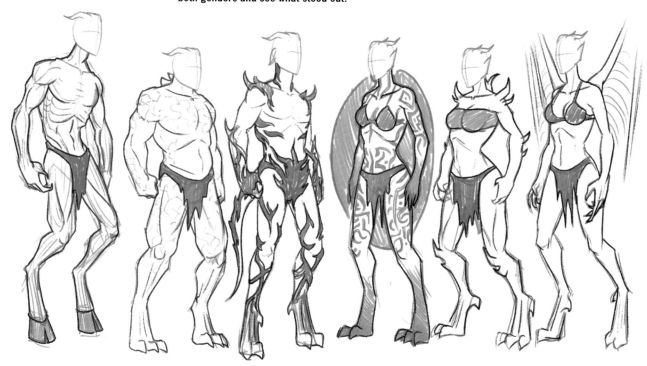

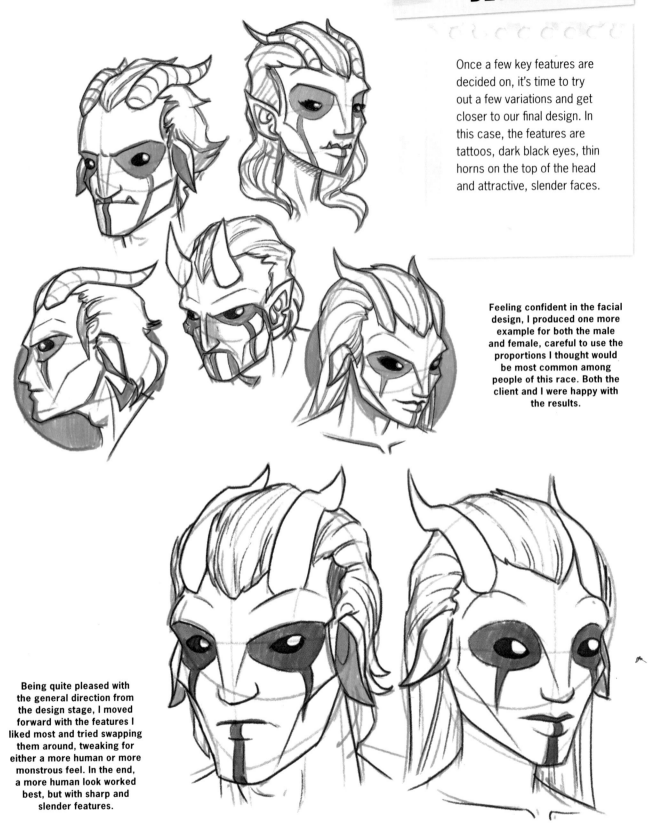

DEVELOP

Once a few key features are decided on, it's time to try out a few variations and get closer to our final design. In this case, the features are tattoos, dark black eyes, thin horns on the top of the head and attractive, slender faces.

Feeling confident in the facial design, I produced one more example for both the male and female, careful to use the proportions I thought would be most common among people of this race. Both the client and I were happy with the results.

Being quite pleased with the general direction from the design stage, I moved forward with the features I liked most and tried swapping them around, tweaking for either a more human or more monstrous feel. In the end, a more human look worked best, but with sharp and slender features.

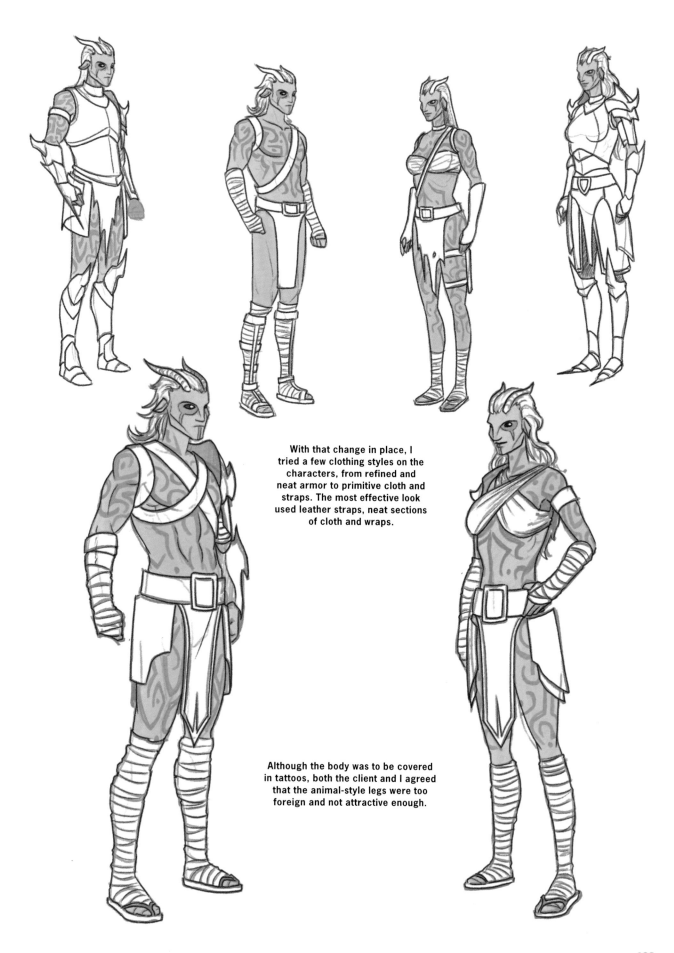

With that change in place, I tried a few clothing styles on the characters, from refined and neat armor to primitive cloth and straps. The most effective look used leather straps, neat sections of cloth and wraps.

Although the body was to be covered in tattoos, both the client and I agreed that the animal-style legs were too foreign and not attractive enough.

DELIVER

For deliverables, I produced a refined concept for both the male and the female, and a variant sheet.

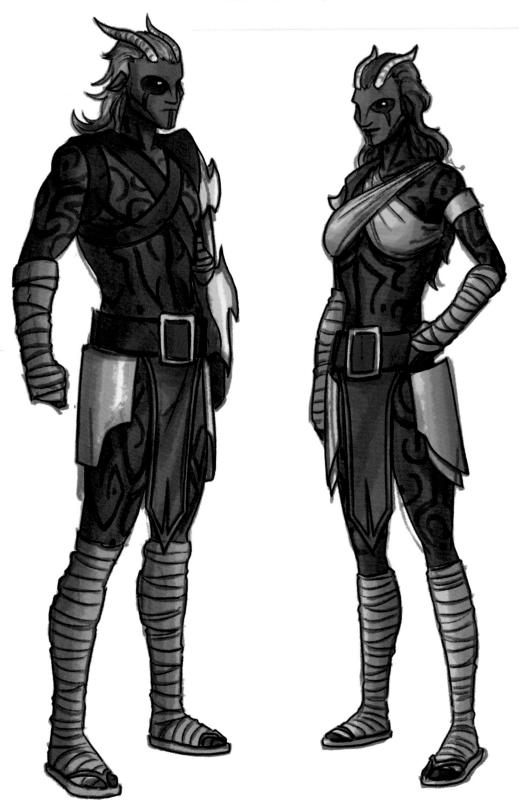

OUTCOME

The deliverables chosen included a male and female final concept piece in a relaxed painted style for the 3-D modelers and character designers to work from, along with a variant sheet to demonstrate what different styles of clothing and what different faces, body types and genders often look like.

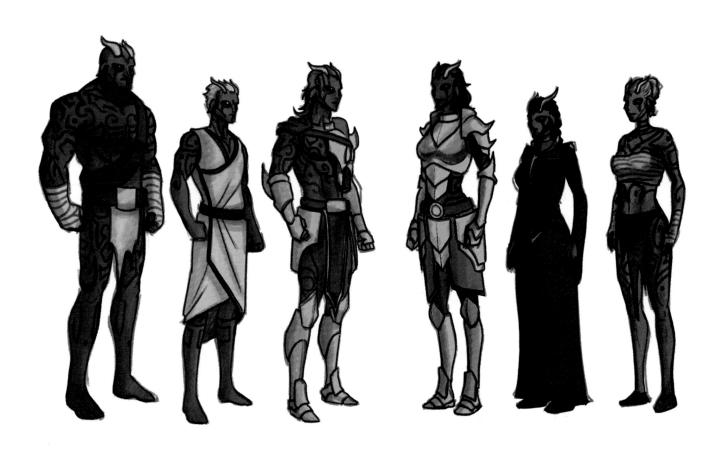

THE TALE TELLER

The Tale Teller is the main character in an animated short of the same name. He is an old traveling storyteller who collects the world's most precious tales from far and wide. In the animation, we'll see him enter a city, whereupon he looks for an opportunity to pass on his stories to those they will help most. His design should be stylistically appealing, with an emphasis on using interesting shapes to create appeal, while keeping the final design simple enough to animate without too much detail needing to be constantly recreated. This character was originally developed for an animated short roughly 8–10 minutes long, intended for internet release.

Author's Note

This example is from my own personal project, an animation I created called The Tale Teller. The following pages show you my own brainstorming process and the development of the design for the main character, from rough sketches to final animated character!

DISCOVER

MARKETPLACE RESEARCH

There are three core audiences who would identify with the production:

1. Teenagers and young adults interested in or studying art or animation.

2. Children and parents/grandparents drawn to charming classical storytelling.

3. People who like to view and share sentimental/poignant short videos.

All three of these areas are broad, and with a high quality production, are likely to be engaged in sharing the animation through social media, as the final self-contained story will be a very shareable YouTube video.

DESIGN RESEARCH

The visual style of the animation will be inspired by Disney/Pixar animated shorts, drawing in particular from the Pixar short *One Man Band*, which is also based in a medieval-style city square with a hint of seemingly Eastern-European aesthetic. The characters in the final animation should all be clearly identifiable, and use sharp edges and blocky shapes to create a clean but simplistic design—a modern twist to a classical-themed animation.

CONCEPT REFINEMENT

The Tale Teller should be visually inspired by pigeons, partially in shape and primarily in color. The character himself will be followed around by pigeons throughout the story. Pigeons are historically message carriers and symbols of home, which is fitting since the Tale Teller is homeless, so his home travels with him. As their design should be symbiotic, the pigeon will also be included in the Tale Teller's design process.

DESIGN

I begin by playing with interesting shapes around core features of the character's face. There are three aspects of the face that should stand out: his beard and facial hair (to show wisdom and age), his eyes (to be aged but kind/wise, perhaps with spectacles) and his nose, which should be crooked or prominent (to make him look quirky).

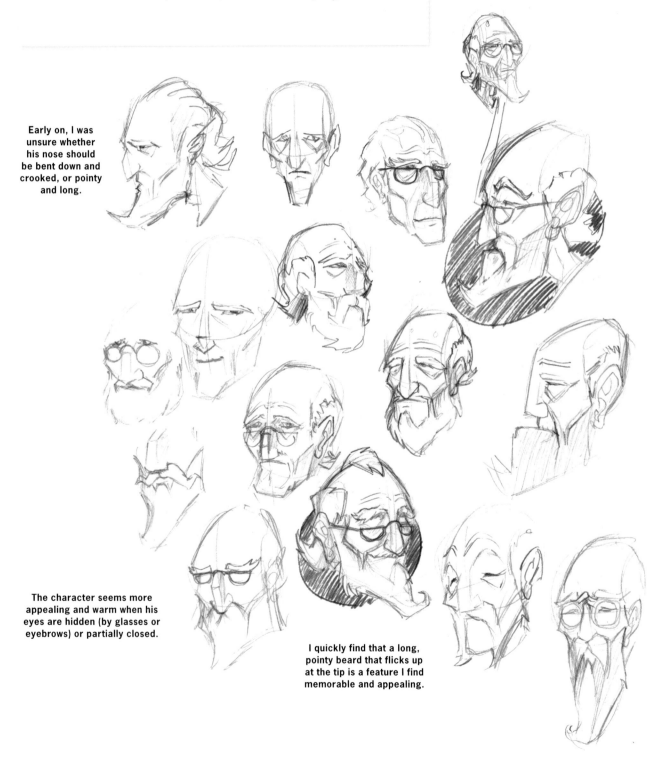

Early on, I was unsure whether his nose should be bent down and crooked, or pointy and long.

The character seems more appealing and warm when his eyes are hidden (by glasses or eyebrows) or partially closed.

I quickly find that a long, pointy beard that flicks up at the tip is a feature I find memorable and appealing.

DEVELOP

As the design of the head and face begins to feel solid, I start to experiment with clothing and body types that complement the same aesthetic. A hunched back with very thin, long and crooked limbs almost immediately becomes the clear choice.

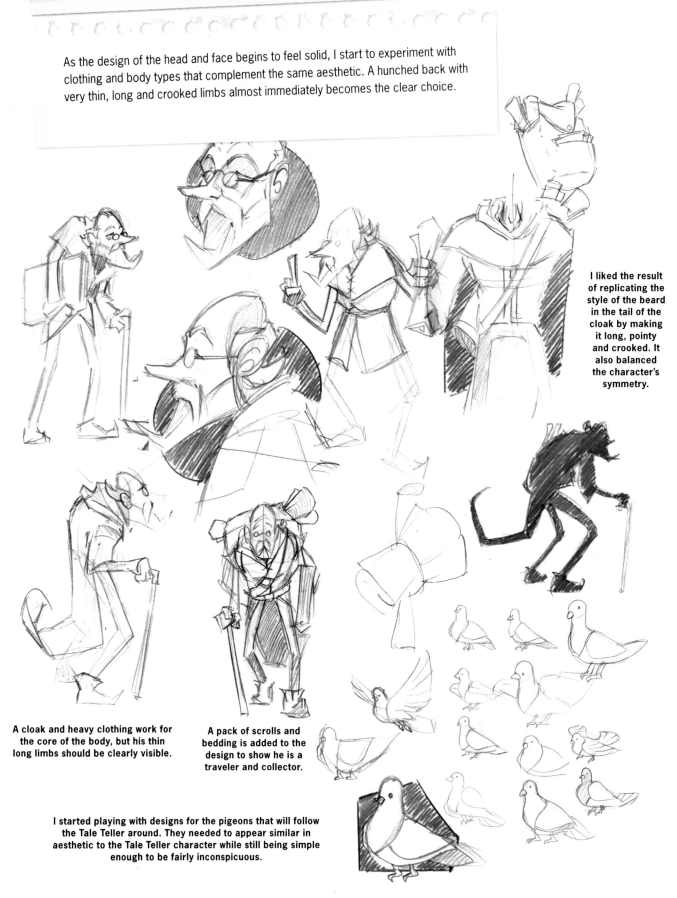

I liked the result of replicating the style of the beard in the tail of the cloak by making it long, pointy and crooked. It also balanced the character's symmetry.

A cloak and heavy clothing work for the core of the body, but his thin long limbs should be clearly visible.

A pack of scrolls and bedding is added to the design to show he is a traveler and collector.

I started playing with designs for the pigeons that will follow the Tale Teller around. They needed to appear similar in aesthetic to the Tale Teller character while still being simple enough to be fairly inconspicuous.

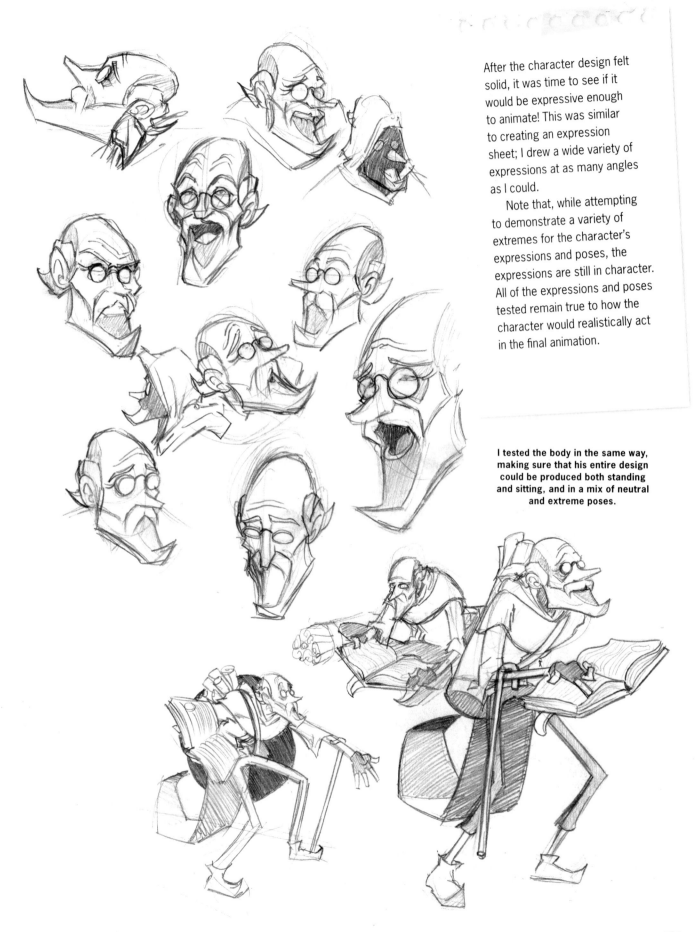

After the character design felt solid, it was time to see if it would be expressive enough to animate! This was similar to creating an expression sheet; I drew a wide variety of expressions at as many angles as I could.

Note that, while attempting to demonstrate a variety of extremes for the character's expressions and poses, the expressions are still in character. All of the expressions and poses tested remain true to how the character would realistically act in the final animation.

I tested the body in the same way, making sure that his entire design could be produced both standing and sitting, and in a mix of neutral and extreme poses.

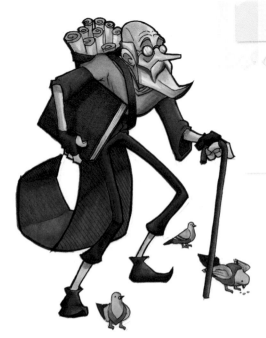

DELIVER

For deliverables, I produced a refined colored character concept on paper and a vector illustration in the same format and colors as would be in the final animation.

Finishing the Colors

After playing with the colors, the scheme I settled on mirrored the colors of the pigeons that follow the Tale Teller around: a turquoise shawl and purple cloak with brown and gray throughout. Once the final concept piece was created on paper, the art was scanned into the computer and recreated digitally in vector format, in Adobe Animate CC.

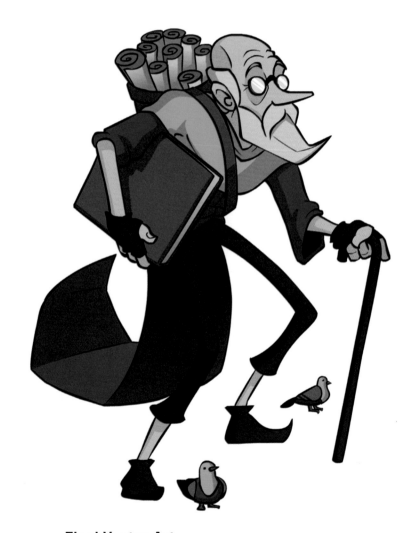

Final Vector Art

The final vector concept art was pivotal in the creation of the animation. So much so, in fact, that in literally every scene in which he was animated, this piece of character art was brought in and used directly as a reference for body and head proportion, and as a guide for poses and colors. These deliverables really matter to the production process!

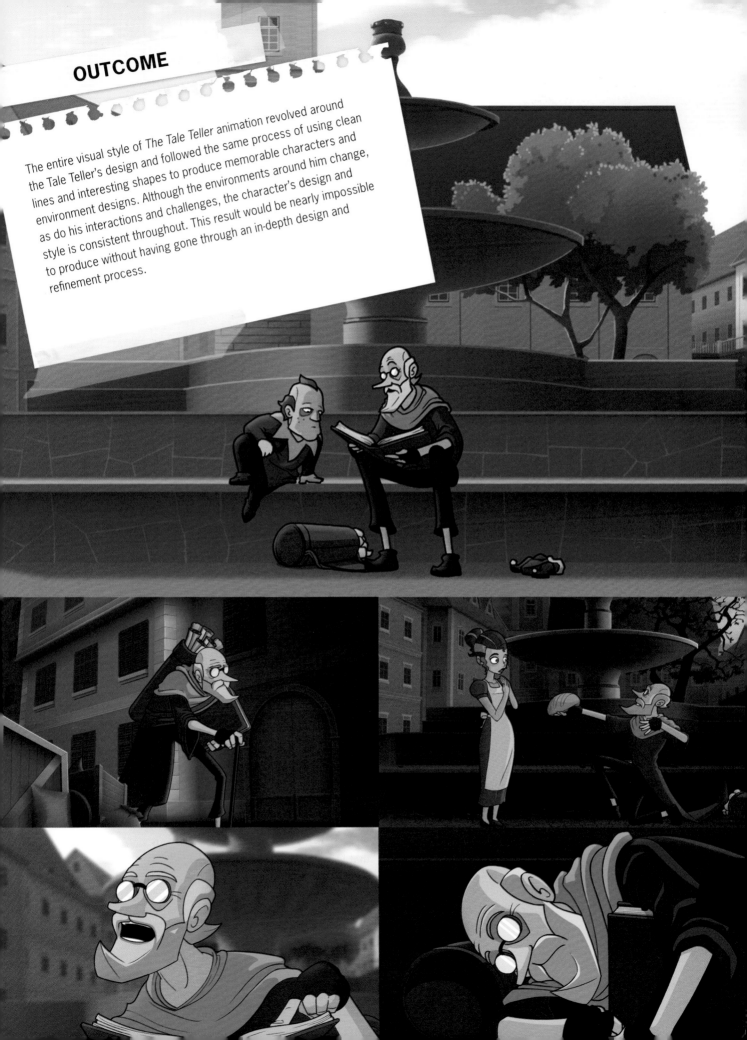

OUTCOME

The entire visual style of The Tale Teller animation revolved around the Tale Teller's design and followed the same process of using clean lines and interesting shapes to produce memorable characters and environment designs. Although the environments around him change, as do his interactions and challenges, the character's design and style is consistent throughout. This result would be nearly impossible to produce without having gone through an in-depth design and refinement process.

IMPORTANT STUFF TO KEEP IN MIND

COPYRIGHT

Copyright refers to the legal right to use or distribute something. Applied to character design, if you invent your own character for your own project, you are the innate owner of the copyright to that character, and if someone else makes a product using the character you invented, they are infringing upon your copyright. If a client gives you a design brief and pays you to design their character, the copyright belongs to them as it is their original idea, and they are paying you for your services in designing the character. As an artist, you should never infringe on someone else's copyright, in the same way that you wouldn't want someone to steal your work and claim it as their own.

TRADEMARK

A trademark is a license granted to specific things such as logos, sounds, phrases, color combinations, designs and so on. It is a legal registration of that item marking it formally as property to be available to use commercially or otherwise, by the entity or person it is registered to. Examples include the golden arches that form the *M* of the McDonalds logo, the Nike phrase "Just Do It," the YouTube logo, and the list goes on. You may trademark your design or logo, though it isn't necessary for legal protection of your designs, just recommended if the design is intended for heavy use in a public or commercial setting.

INTELLECTUAL PROPERTY

Intellectual property is similar to copyright in that it refers to ownership, but instead of that ownership being a design or character, the property in question is an idea, hence intellectual property (or IP for short). IP is just as important as copyright, but even trickier to prove ownership for. With copyright, you can find ways to prove you created the original idea if it was your creation, but it's much harder to do this with IP. The best way to safeguard your ideas is to keep notes and evidence of them in a safe place, while also ensuring you have written acknowledgement of your ownership of your ideas by people you choose to involve in your project. IP can also be owned by more than one person. For example, if you're illustrating a comic book series with a friend of yours who is writing the story, you both by default would own 50 percent of the intellectual property unless you form a written agreement stating otherwise.

WHAT IT ALL MEANS

"Why mention all this technical mumbo jumbo?" you ask, "Why can't I just draw cool characters?" Well, you can! But I believe that everyone has great potential. If you work hard enough and long enough, and you have the right idea, your cool character may very well be the next big thing, and everyone wants a piece of the next big thing. It's important to know some of the basics regarding copyright and property laws, just so you know how to keep your content safe and in your control, and how to properly respect other people's content at the same time.

CONCLUSION

It's been a long and fun journey taking you through some of the finer points of the design process! I hope you've enjoyed yourself and that this book has been of some help or inspiration to you. This is my first-ever book, and I'm really glad you took the time to pick it up. Character design is, by far, my favorite thing to do when it comes to drawing, and when I first discovered art, creating characters for my own worlds and stories was something that filled my life with enjoyment and encouraged my imagination and ambition to grow. Thus began my journey down a path that has led me to a career as a full-time artist, which is something I am grateful for every day.

I wish you all the best of luck on your creative journey, and I hope that the characters, worlds and stories you create bring you loads of happiness and success. Your imagination and hands working together can be a powerful thing, and while there are plenty of "how to draw this or that" books out there, I hope I've been able to offer you a unique perspective on how to create something of your very own, any time you want to!

INDEX

a content + ecommerce company

Other fine IMPACT books are available from your favorite bookstore, art supply store or online supplier. Visit our website at fwcommunity.com.

20 19 18 17 16 5 4 3 2 1

DISTRIBUTED IN CANADA BY FRASER DIRECT
100 Armstrong Avenue
Georgetown, ON, Canada L7G 5S4
Tel: (905) 877-4411

DISTRIBUTED IN THE U.K. AND EUROPE
BY F&W MEDIA INTERNATIONAL LTD
Brunel House, Forde Close, Newton Abbot, TQ12 4PU, UK
Tel: (+44) 1626 323200, Fax: (+44) 1626 323319
Email: enquiries@fwmedia.com

ISBN-13: 978-1-4403-4494-7

Edited by Noel Rivera
Editing assisted by Christina Richards
Designed by Jamie DeAnne
Production coordinated by Jennifer Bass

ACKNOWLEDGMENTS

First and foremost: Kate, you get both a dedication *and* an acknowledgement. Lucky girl. I couldn't have done this without you. I've had dreams and ambitions since I was a kid, but it was only since I met you that my dreams really started becoming realities. Thank you—I am a lucky guy.

I would like to thank Christopher Hart for being my childhood inspiration and sparking my passion for drawing and how-to-draw books. You are a wonderful example to me, and I consider myself lucky to know you as a friend.

Thank you Susan, for taking me seriously when many others didn't, and for guiding me through this process with kind and considerate help and reassurance.

Thanks Mona, for finding me and inviting me to jump on board with IMPACT, and to Noel, for being a great support and guiding me through the long endurance race of writing my first book.

Thanks go to my high school art and design teachers Frank and Nadine, for being incredible instructors in my schooling, and wonderful friends and mentors afterwards.

Endless thanks to my wonderful community from my *Draw with Jazza* YouTube channel. It is your support and kindness over the years that have made projects like this possible. Thanks for not only tolerating, but encouraging and enjoying, my immature jokes and often bizarre content.

Thanks Mom and Dad! I must have looked insane with all my random projects as a kid, but look what I'm doing now! True, I still have tons of random projects, but thank you for your support and for encouraging my passions!

Last, but most certainly not least, thank *you* for reading my book! It means the world to me. I appreciate you, and I wish you all the best with your art and on your creative journey.

Metric Conversion Chart

To convert	to	multiply by
Inches	Centimeters	2.54
Centimeters	Inches	0.4
Feet	Centimeters	30.5
Centimeters	Feet	0.03
Yards	Meters	0.9
Meters	Yards	1.1

ABOUT THE AUTHOR

Josiah Brooks (known as Jazza online) is an artist and animator best known for the educational and entertainment content on his YouTube channel *Draw with Jazza*.

Josiah began drawing and inventing characters and stories at the age of eleven. At thirteen, he was creating animated content for the Internet. After graduating high school, he continued to create his own content as a self-employed game developer and independent animator.

In 2012 Josiah created his YouTube channel to share his self-taught techniques for character design, illustration and animation, and the channel grew rapidly in popularity. As his community grew, he gravitated toward producing standalone educational content and artist resources for his website, jazzastudios.com.

Josiah's book on character design (the one you are reading right now) is the first book he's ever written and had published. As it's been something he's wanted to do since he was eleven years old, he's incredibly grateful that you've taken the time to pick it up and read it!

He's also fairly certain that most About the Author sections are written in the third person, and as such, he will continue to write this way until otherwise corrected, even though he feels slightly silly doing it. He is also quite surprised that you're still reading, as he thinks most people skip this bit. Good job!

IDEAS. INSTRUCTION. INSPIRATION.

Check out these *IMPACT* titles at impact-books.com!

These and other fine *IMPACT* products are available at your local art & craft retailer, bookstore or online supplier. Visit our website at impact-books.com.

Follow *IMPACT* for the latest news, free wallpapers, free demos and chances to win FREE BOOKS!

Follow us!

IMPACT-BOOKS.COM

- Connect with your favorite artists.
- Get the latest in comic, fantasy and sci-fi art instruction, tips and techniques.
- Be the first to get special deals on the products you need to improve your art.